the animator's guide to 2d computer animation

Hedley Griffin

Focal Press

OXFORD AUCKLAND BOSTON JOHANNESBURG MELBOURNE NEW DELHI

Focal Press
An imprint of Butterworth-Heinemann
Linacre House, Jordan Hill, Oxford OX2 8DP
225 Wildwood Avenue, Woburn, MA 01801–2041
A division of Reed Educational and Professional Publishing Ltd

A member of the Reed Elsevier plc group

First published 2001
© Reed Educational and Professional Publishing Ltd 2001

British Library Cataloguing in Publication Data
A catalogue record for this book is available from the British Library

Library of Congress Cataloging in Publication Data
A catalogue record for this book is available from the Library of Congress

ISBN 0 240 51579 X

Composition by Genesis Typesetting, Rochester, Kent
Printed and bound in Great Britain

dedication

To Lady Paddina and Gordon Cole, for without their constant guidance, loyalty and friendship, life would have no meaning.

epigraph

If Mies said, 'God is in the details', and Garrick said, 'God is in the pixels', in reality, is not God in all things, waiting patiently for our eyes to adjust to the light?

contents

foreword by Tony White

Animation and animators have been liberated by the technological developments of the past decade or so. Where once it required a huge team of specialists to create an animated production, now the whole process can be implemented on a desktop computer in the animator's home, if required. Animation had always been very much a 'cottage industry' – outside of the big, self-contained Hollywood studios, where aspects of the work were sent out for processing, whether it be 'inbetweening', 'trace & paint', 'sound editing', 'rostrum camera work' or 'film processing and transfer'. Animation is still no less a cottage industry in many ways but, even though the need for an animator to send out the work is much less imperative these days, the workplace is far wider and the need for the big, cumbersome, uneconomical studio environment is no longer necessary. Now a modern, independent animation studio can literally be based worldwide, with modern technological developments allowing dispersed members of a production team to work and communicate with each other via their computer modems. The now recognized global village of 'community' is no less a global village of 'animation'.

Hedley Griffin's book is a major step forward for the aspiring animator who wishes to take advantage of the amazing capabilities modern animation technology offers. From beginning to end, the animation process is described and defined in a way that is easily accessible to anyone, whether they be the most stumbling of beginners or the most accomplished of professionals. Software, systems and a stage-by-stage outlining of the animation process is clearly laid out, taking the mystery of the contemporary animation process and making it understandable and appealing. Focusing on the very best of animation software, Hedley walks us through the processes that once were extremely time and labour consuming and, in many cases, quite frankly, messy and tedious. The tedium of animation can never entirely be removed, however, in that it is essentially a painstaking, frame by frame, many frames per second process. But at least the animator can now be liberated in the main from antiquated and age-old processes that have rapidly faded from the mind. Hedley shows how space, time and money are saved through the miracle of the latest computer technology, which has elbowed its way into the industry over the past ten years or more. This book is therefore a major road map of the course that might be plotted by the aspiring animator, in pursuit of expression. As a seasoned traveller across this terrain, I have also learnt much from it myself. We all can.

The revolution that has occurred in animation is the same revolution that has occurred in all other aspects of our lives, entirely a result of the advancement of computer technology and techniques. The much spoken of 'Aquarian Age' in the past is very much upon us today. The world has shrunk, individuality abounds and communications between us all is instant and limitless. The animation industry very much reflects this transformation too. But animation software alone does not guarantee a good film, however, and the timeless process of inspiration and communication between a film-maker and their audience will never change. An animator can have all the most amazing systems and software in the world and still produce an animated film that misses the mark with their audience. (I awkwardly say 'film' here as the reach of animation stretches far beyond the confines of merely 'film' these days, embracing video, TV and web distribution too.) Better technology alone does not make for better animation. The

creator of animation still has to learn to express themselves in a way that audiences can appreciate and enjoy. The script, as we know, is all important, so is just how the script is interpreted on the screen. However, with the proliferation of animation 'gismos' out there, it does make the life of the animator so much easier in physically achieving what is in their mind's eye. This liberation is only possible because of the revolution of technology that has occurred. Hedley Griffin's book is a major doorway through which the aspiring animated film-maker may step in order to embrace the wonders of creation that are now to be found, literally, with the click of a mouse. I thoroughly recommend that all those who aspire to making better and more efficiently produced animated movies should get this book as their starting place for the journey, or as renewed inspiration for those already journeying. It is a most valuable travelling companion.

Tony White

acknowledgements

I would like to express my warmest thanks to those who have provided case studies and artwork, and all those other people who have contributed with their kind assistance and endless effort in helping to publish this book:

To Philip Pepper for his case study using Animo, to Marie Beardmore for her case study using Toonz, and to Alan Rogers and Peter Lang at the Cut-Out Animation Company for their time and enthusiasm describing CreaToon.

I owe special thanks to Hollie Armstrong at Cambridge Animation Systems, Claudio Mattei at Digital Video in Rome, Sadie Paris at Bubble and Squeak, Marleen VanBrabant at Androme NV, Hakan Guleryuz and Cemil Turun at Yogurt Technologies, Sheldon Linker at Linker Systems, Justine Whitehead at Guru Animation, Karina Bessoudo at Toonboom, Andy Blazdell at CelAction, Julian Zhu at Retas!Pro, Martin Phelan at Crater Software, and Corinne Bouilly at MediaPegs.

A very particular thank you is due to Marie Milmore and Christina Donaldson at Focal Press for their consistent support, patience and perseverance in helping me put this book together.

introduction

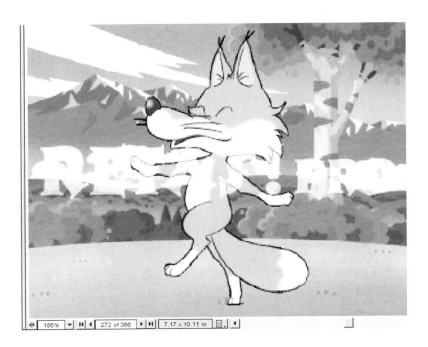

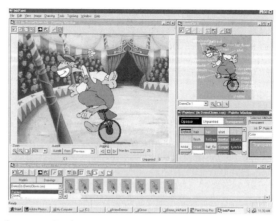

Fig. I.1 Animo software from Cambridge Animation Systems.

For the complex processing of 2D computer animation, designed to replace the tedious and repetitive tasks involved, there are two leading systems available at this time in the Western world: **Animo**, produced by Cambridge Animation Systems, and **Softimage Toonz**, designed by Digital Video Srl., based in Rome, and marketed through Avid. There are other cheaper systems on the market, but for the serious professional it would be advisable to choose either one or other of these two. Both systems are very sophisticated and able to adapt to a wide range of styles and techniques needed in an ever expanding range of 2D animation, including 'cut-out' as well as all forms of drawn artwork. From scanning paper drawings through to outputting onto film or videotape, many of the digital production techniques emulate traditional animation methods. A digital production network of 12 systems can zip through a 22,000-drawing episode in less than ten days!

When DreamWorks produced *The Prince of Egypt* they used several 2D image processing programs, including PhotoShop, Chalice, Eddie and Elastic Reality, as well as Animo as the central production tool to create the nearly 2,000 shots in the 90-minute film.

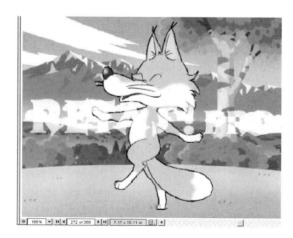

Fig. I.2 Retas!Pro.

Fig. I.3 Archer software from Yogurt Technologies, Turkey.

The long-standing methods of working with cel acetate and filming the finished artwork under a rostrum camera are now becoming redundant. Limited and time-consuming, these methods are also more expensive to employ than Animo, Softimage Toonz, or one of the other systems available.

In the East, **Retas!Pro** is the award-winning, market leader, helping to produce an enormous range of feature films as well as other major productions. This system is now available in the West and more and more distributors are being established for this product.

The software for **Archer** was written in Turkey, but is now distributed in the UK. A scaled-down version of Animo, it is available at a cheaper price, but needs to go a great deal further before it can match the sophistication and elegance of Animo.

Axa Team 2D Pro is a 2D system, very much associated with the old traditions of drawn 2D animation. It uses either an *XSheet* or *Camera* aspect as the two main windows to composite a

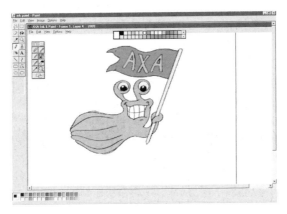

Fig. I.4 Celmation Axa software.

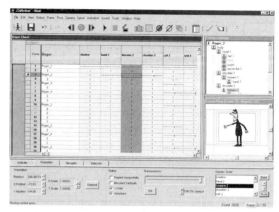

Fig. 1.5 CelAction software. (Character copyright 1999 Mark Baker, program screenshots copyright 2000 CelAction.)

scene together. Artwork is scanned in, painted and presented under the 'camera' in a very simple fashion. One of the cheaper systems available, it is very good value. However, again, you get what you pay for.

CelAction is an extremely simple system, easy to understand and use, written for the specific use of cut-out animation. It does rely on the artwork being drawn either in Adobe PhotoShop or Illustrator first. The image is then imported into CelAction where it can be moved around the screen very much in the same way cut-out artwork has always been manipulated under the camera. One of the cheaper systems from the UK, the cut-out animator would quickly appreciate its potential.

Crater Software of Canada, the publishers of **CTP** cartoon animation software, is a serious competitor in Europe, providing the usual range of animation packages. Like so many of the easier systems, CTP was originally conceived as an in-house proprietary product designed by

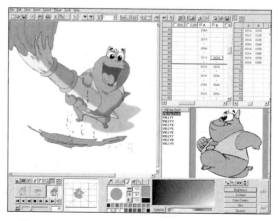

Fig. 1.6 CTP software from Crater.

animators, employing software engineers to fulfil their specific needs. CTP is a post-paper production tool for creating cartoons. Animators acquire their original drawings via scanner, video input, or from a computer-generated file, and the artwork is placed into CTP for inking and painting the cartoon cels. The inked and painted sequences of images (or layers) are then animated under a virtual animation camera, to create pans, zooms, and rotations on the animation layers, as well as animated transparencies and blur effects. Once all the layers, including overlays and backgrounds, are animated under the virtual camera, they are composited and output directly to video, or onto a storage media for transfer onto film. Like Toonz, CTP is a raster-based system, but although easier to use without separated modules, it does not have the full capabilities of Toonz or Animo. However, it does warrant a lower learning curve taking, perhaps, only a week to master the interface.

CreaToon is a cut-out animation system for PCs. Similar to CelAction in its conceptual design, it bases its construction of an animation character on a hierarchical skeleton of items that then need to be manipulated frame by frame, in the typical cut-out manner, exactly in the same way as you would under a traditional rostrum camera.

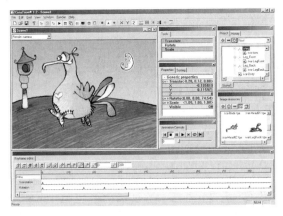

Fig. I.7 CreaToon software.

Linker Systems from California have produced a package called **Animation Stand**. Key features of the product include multiplane camera control, cel painting and blend shading, audio editing, production cost reporting and easy output to film, HDTV, video, QuickTime and files. The system covers all major platforms: Mac, SGI, Windows (95, 98, 2000 and NT).

MediaPegs is both a vector- and pixel-based system, including several modules, *Integrator, Animation and Layout Scanning, Painting and ColourModels, Vector Painting, Exposure Sheet and Compositing Visualiser, Camera Editor and Mutiplane, Recording, Pegs Office, 3Dtoonkit, Lip Synch. Integrator* is the primary control panel, which simplifies the work environment on a computer station to maintain data consistency between all the users:

● All camera motions (complex pan, deep zoom, tilt, automatic preview, control of slow-in/out).

Fig. 1.8 Animation Stand from Linker Systems, USA.

- Powerful pegs motions (complex trajectories, size animation, multiplane).
- Painting with textured colours and mapped textures.
- User-friendly animated effects (open filter architecture including motion blur, backlit, auto highlights and shadows, drop shadows).
- Powerful interactive compositing.
- Real time colour preview.

Softimage Toonz was designed by cel animation artists and producers. It is an XSheet-driven digital ink and paint program that traces the steps of hand-drawn animation, giving the users the familiar tools and processes and all the efficiencies and options of a digitised medium. Thanks to its simple interface, Toonz is extremely easy to learn. Even non-computer oriented animators can feel comfortable with the software from the very first time. Moreover, Toonz evolves very rapidly: these are some of the features of the new 4.4 version:

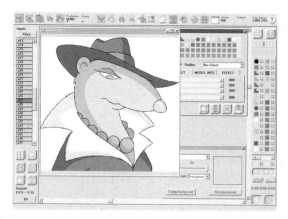

Fig. 1.9 MediaPegs software.

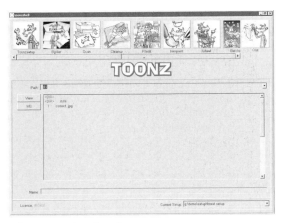

Fig. I.10 Softimage Toonz from Digital Video, Rome.

- It now runs on Linux platforms.
- While the *Scan* module directly supports and will continue supporting specific scanner models as in previous releases, it is now also able to support any other TWAIN-compliant scanner via the TWAIN drivers provided by the scanners' vendors.
- It is now possible to render final images onto a digital disk recorder through its Ethernet port without having to save files on hard disk.
- The architecture of the composer has been changed to enable the users to run the new Toonz *Particle&Fx* plug-in. It will provide the users with a large number of very sophisticated special effects, such as the atmospheric ones, to be realised with the particles generator.

Fig. I.11 *Coccobill* made using Toonz. (Copyright De Mas & Partners.)

ToonBoom Technologies produce a completely vector-based, 2D software package, called **USAnimation**. USAnimation 5.0 is the latest version and supports Macromedia's **Flash**, making it the first available in the ink and paint market to include this feature.

- Compared to bitmapped technology, vector-based systems preserve line quality, remaining true to the animator's original artwork at any scale without pixelisation.
- Resolution independence eliminates quality constraints. Material can be imported or exported without having to set and reset parameters. Scanned-in material is vectorised, and output resolution can be changed at any point without having to redraw, rescan or repaint.
- Animation can be rendered in several formats including PAL/NTSC video, HDTV, DVD, 35 mm, 70 mm and IMAX.
- Vectorisation allows true multiplaning in multiple layers with object rescaling – all without pixelisation, eliminating the need to redraw material every time the camera changes distance.
- Smaller vector file sizes also mean that material requires less disk storage space and that it can be transferred much more quickly.
- Resolution independence is an asset in 2D integration with 3D animation.

Fig. 1.12 ToonBoom Technologies. (USAnimation V5 screenshot using Turtle's Island, image courtesy of Les Productions La Fete/Mimosa.)

Much of the software advice in this book refers to **Animo**, but some of it can be applied to other systems. Each system has its own unique way of naming different modules, applications and tools, and its own unique way of producing an animated image. At the same time, most animation systems work on Windows NT as their basic operating system, but some of the

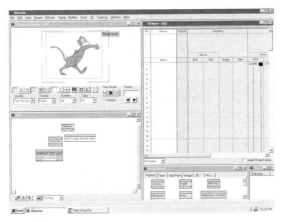

Fig. I.13 Animo's *Director* module.

software programs will also work on Windows 95, 98, 2000, SGI and Macintosh computers. Therefore the combinations and permutations available do not allow for every situation to be described and covered in this book.

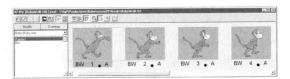

Fig. I.14 *Bobo the Monkey* using Animo.

Capabilities

It is a common belief amongst the uninitiated that computers are capable of producing all the animation at a touch of a button without the animator needing to do any drawing. This is very far from the truth as the computer only helps in processing the final result. However, these systems do have the ability to 'inbetween' in one sense, but not to create inbetween animation drawings.

When creating movement with a cycle of drawings the computer can enlarge, reduce, tint, change the opacity, blur, flip or rotate the image from one point in the screen to another, filling in all the inbetweens, thereby saving a great deal of work that would have been done using the traditional method of cel and camera. In addition, if eight drawings are used for an animation cycle, for example, and repeated for a complex movement, it is only necessary to paint the eight original drawings to complete the final scene.

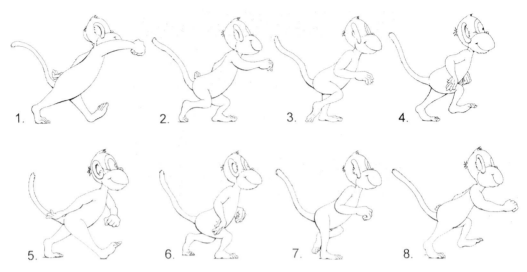

1. 2. 3. 4.

5. 6. 7. 8.

Fig. I.15 A typical walk cycle.

Another great advantage of these computer systems is the ability to create soft tones, shadows, textures, thickening and colouring of the final line drawings and many other effects. Some of these attributes can be used to create very realistic and stunning images.

Digital images from live action or 3D sources can also be introduced into a scene and matched together. This process, performed on film in the traditional way, can be very expensive indeed.

Background artwork, drawn and painted as normal, can be changed, colour corrected or even enhanced by a correction of the saturation or hue. Parts of an image can be manipulated to

Fig. I.16 Line drawing from *NunsDrakka's Child*.

Fig. I.17 The finished painted artwork from *NunsDrakka's Child*.

Fig. I.18 *Noir* using Toonz.

include different forms of matting or degree of transparency. Additional time saving can be made by scanning in a large background, and using small parts of that image to adapt for other scenes. In traditional methods of cel animation the smaller parts of the background would need to be recreated. Some of these systems are modular, dealing with different applications of the imagery, and the following chapters will explain the reasons and tasks needed before completing the final scene as one might under a rostrum camera.

Modules

The first module, *ScanDrawings*, usually using an A3 black and white scanner, inputs the paper animation drawings. Whether the pegged 12-inch field or 15-inch field paper drawings are fed in manually or automatically, the system will identify the pegging and keep the registration of the drawings true. The system identifies each drawing with a numbering arrangement that allows for copying, moving or deleting.

The drawings are then processed in the next module, *Image Processing/Analyser*. To the traditional animator, this module might seem unnecessary at first, but it is crucial to the activity of the computer system. It also helps determine the feel and strength of the lines, establishing the style of the animated drawings, and faithfully preserving the original qualities of the artwork. It is in this module that the software produces regional areas that define the parts to be painted.

The third module, *Ink and Paint*, colours not only the body of the drawings but also the line drawings themselves. Any unwanted gaps in the regional areas may be automatically closed to allow for fast painting. It is also in this mode that blends can be introduced to soften the colour grading to create tones and shading. Little specks of dirt, smudges and illicit marks can be easily erased leaving the final painted animation perfectly clean. There are also ways of testing the results to check that all the areas are coloured correctly and properly filled.

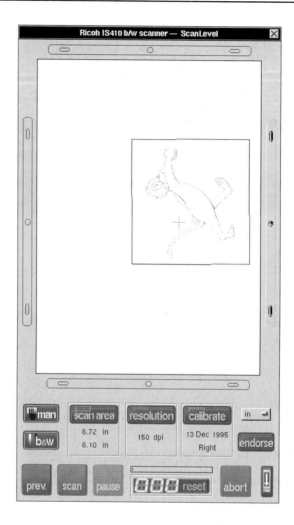

Fig. 1.19 and 1.20 Animo's *ScanDrawing* module.

The colouring of the drawings is controlled by a colourmodel. By preparing multiple palettes, the painted drawings can be automatically recoloured without having to be repainted. This is particularly useful if an animation character needs to be colour-corrected, for a night scene for instance. Any changes made to the palette will automatically follow through the computer system to affect any stage of the process. Even when the scene is being prepared at the end of the process, by changing the palette the

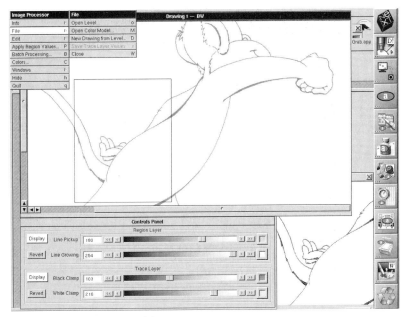

Fig. I.21 Animo's *Image Processor* module.

colour of the character can be fine-tuned as required. Palettes can be created for special effects such as explosions, backlighting, underwater and textures. When deciding the colours within the palette it is extremely useful to see the character against the final

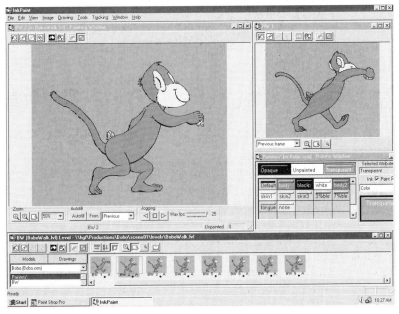

Fig. I.22 Animo's *InkPaint* module.

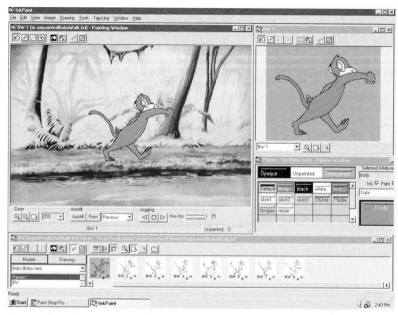

Fig. 1.23 Background used in Animo's *InkPaint*.

background. Without this ability the colours of the character can appear quite different laid against, say, a white or grey background, not reflecting a true balance of the expected result.

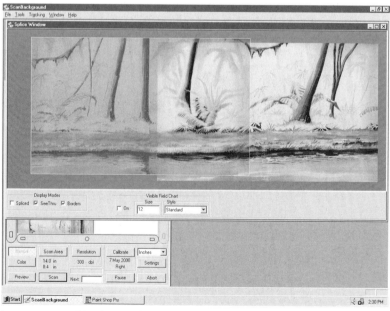

Fig. 1.24 Splicing sections of background together in Animo's *ScanBackground*.

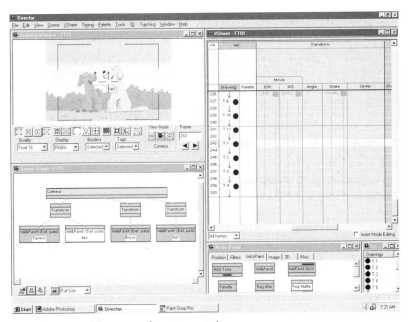

Fig. I.25 Animo's *Director* with a scene from *Furry Tales*.

Since the invention of these types of computer systems animation has never had so much freedom of style. No longer is the animator restricted to the black line and flat colour infill, confined by the limiting use of cel acetate.

Oversized artwork, such as panning backgrounds and overlays, can be scanned in sections on a colour scanner and then seamlessly reassembled within the computer, using *ScanBackground* module. When all the different elements of the final scene are ready, whether they are painted drawings, backgrounds, live action or 3D clips, they are collated within *Director* or *Compositor*.

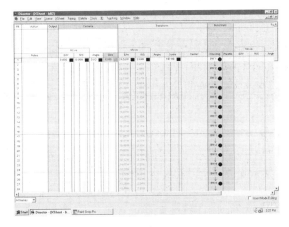

Fig. I.26 Animo's *XSheet*.

As all the different elements are introduced into the scene and placed in the display window, the doping is listed on the *XSheet* (or exposure sheet). Cycles, lip-sync, camera moves, pans and all the usual dope sheet information is defined with key frames. Camera moves and positions can be placed by eye or, for more accurate placement, numerically plotted on the *XSheet*. Any changes to an object in the display window dealing with blurs, opacity, ripples or lighting effects can also be effected by numerical accuracy.

In addition there is no limit to the number of levels that can be placed within a scene. When using cel acetate the recommended maximum number of levels was six. The accumulation of different levels of cel under a rostrum camera would often cause a discolouring of the final image, as well as hide little pieces of dirt, hairs and paint debris; a nightmare for the cameraperson and a hindrance to the perfection of the final film. As a result it was often necessary to repeat drawings onto different levels to keep within the maximum, thus creating unnecessary extra work. The 2D computer animation systems have done away with all these problems and invented new horizons.

The placement of one character in front of or behind another is controlled in the *Scene Graph* or *Composition* window. All the positioning, filters and collation of images are coordinated here. There is also a fully interactive multiplane camera option available, where complex perspective shots can be achieved by setting independent timing and positioning values for each level. Some of the special scene arrangements available on the computer would have been almost impossible on a conventional rostrum camera. Even the simplest moves in *Director/ Composition* could cause difficulties in traditional camera shooting. For example, a rotating character placed over a horizontal or vertical pan has always been very difficult to achieve on the rostrum. Sometimes, a vertical or horizontal table movement on the rostrum is restricted by walls, lights, supporting framework or some other irritating obstacle. There are no such limitations within the computer.

At any stage in the processing of the animation it is possible quickly to run a 'replay', like a 'line test', to see how the work is progressing. This cuts down the need for 'reshoots', which, of course, in rostrum camera terms would involve extra costs. This does not mean that all mistakes are avoided, but it does reduce the risks, allowing for a greater degree of quality control and accuracy.

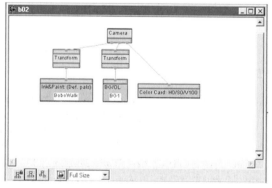

Fig. 1.27 Animo's *Scene Graph* window.

Fig. I.28 Animo's *Replay.*

Once the final scenes are complete, the computer will need to render and output them to disk, film or video. The process can be left to transfer overnight or over a weekend during downtime, or some computers will multitask and allow further work while the rendering takes place. This does tend to slow normal working procedures, but sometimes pressure of deadlines necessitates it.

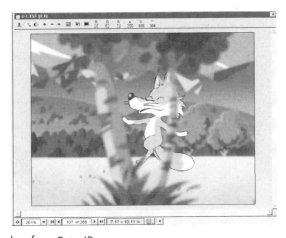

Fig. I.29 *Rendering* window from Retas!Pro.

Operating Systems

Both Animo and Softimage Toonz were originally designed to run on PCs. Animo was initially produced on a Unix-based operating system, called NextStep. The latest version of that system is 1.7. In more recent times Cambridge Animation Systems have produced Animo 3, now available on Windows NT and Silicon Graphics operating systems. Animo 3.1 works with the *Scene III* plug-in which has been designed to integrate with two of the most popular 3D packages available on NT – Kinetix 3D Studio Max and Alias/Wavefront's Maya, also on SG.

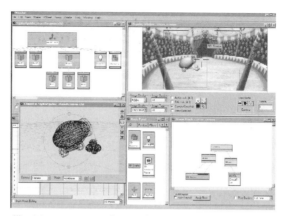

Fig. l.30 Animo's *Scene III* adding an extra dimension to 2D animation with a 3D plug-in.

3D models can now be manipulated within a 2D scene, and allowed to share similar 'toon-shading' styles from conventional cartoon animation.

The NextStep Animo system was quite different from the more recent innovations, and was designed with a strong bias towards vector drawing within the computer as well as providing the normal service for the more common paper-drawn animation. Animo 1.7 is still widely used throughout the animation industry worldwide, but most of the information within this book will concentrate on Animo 2.5 and later versions. The Softimage Toonz is also available on Windows NT and Silicon Graphics operating systems, but the original structure of the system remains the same from birth with modifications introduced with newer versions.

It has been estimated that one workstation can scan 400–800 drawings in one day, or paint, composite and deliver up to five minutes of broadcast quality video. It therefore becomes very difficult for any studio of whatever size to keep track of what has been painted, processed or composed unless some form of record is kept. One procedure is simply to keep a paper progress

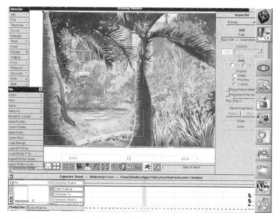

Fig. l.31 Scene from *Eyes of Karras* using Animo 1.7.

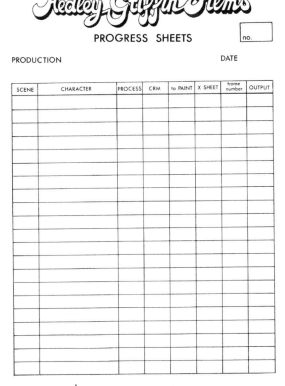

Fig. I.32 Production progress report sheet.

sheet marked up as files become completed. Cambridge Animation Systems developed a digital product, called the Animo Production Tracking System, which will keep all the information stored on a database. This is an advantage for larger studios where the information can be transferred

Fig. I.33 Scene from *Eyes of Karras* using Animo 1.7.

on the Internet or via email, particularly as some of the work is often partly produced abroad.

In Chapter 7 there is a description of all the equipment needed for the complete processing of the animation through to the final video or film. It is highly recommended that anyone purchasing these systems should enrol on the courses provided as there is a great deal to learn. Any manual or book of this nature cannot perform the complete task of explaining the whole process in the same way. Normally, with constant use, a newcomer should start to feel confident after approximately three months, and within the first year be totally competent.

Despite all the information described in the manuals a great deal is missed out. This book aims to help the traditional animator get to grips with an understanding of how the computer systems have been written to provide facilities for their use. One of the great faults of these systems is that the original designers often assume that the average person understands and knows the basic operations of any computer. Unfortunately, many of us sometimes need a guiding hand with even the most basic steps.

chapter 1

storyboarding, animation drawings and scanning

Drawing Style

When it comes to the initial stage of pre-production and preparation we all have heroes and heroines in our minds to inspire us to greater things. It is necessary, sometimes, to find a style to influence some direction in our creative efforts, without losing our own individuality. At the

Fig. 1.1 *Visions of Zak.*

Fig. 1.2 *Visions of Zak.*

Fig. 1.3 *NunsDrakka's Child.*

Fig. 1.4 *Furry Tales* series.

Fig. 1.5 *Furry Tales* series.

same time it is vital to retain our own identity and search for our own creative potential. So, if you have not already developed a unique style of your own, find a form of illustration or cartoon and allow this to influence your own productions. In time, depending on your level of endeavour, you will develop your own personal style. Some people develop early in their lives, some 'fruit' in the autumn years, but within every person's life there is a time for potential 'fruiting'.

It is also essential to keep a vast reference library of magazines, books, photographs, scrapbooks, anything, which can not only help with basic drawing but also provide a source of inspiration. A simple short story may in itself hold a great deal of content, which can only be enhanced with good illustrations and graphics.

Imagination is the result of living many lives, and while life provides us with such rich experiences we should take advantage of what is offered and record events to help express our creative abilities. In other words, keep a doodle book, a scrapbook, a diary of ideas, anything where you can record rich fodder for future productions.

Storyboarding

One of the first rules to consider when storyboarding for any production is not to be inhibited with concerns of production techniques or limitations of the process. Let your imagination run free. The more extravagant and wild some ideas are the more exciting the final product might be. It is always possible to alter your initial thoughts at a later stage if they become impracticable. Some of the most exciting images for storyboarding have developed from the genre of the comic strip. Many adult graphic novels are illustrated with unusual 'camera' angles and original perspectives. They can be a rich source of inspiration for storyboarding. However,

Fig. 1.6 Graphic novel.

beware – some of these strips work well in their format, but become a little difficult to translate into film. 'Continuity' and film grammar have to be considered, otherwise the audience may become confused. It is often thought bad form to 'cross the line'.

Whilst visualising the plot it is always necessary to remember the audience who will see the finished product for the first time. However clever the directing, angle shots and unique style of the delivery, will the audience follow and understand the story? Does the story flow properly and is the continuity correct?

The storyboard should, as far as practicable, be prepared with as many finished drawings as possible. Rough, unfinished drawings can lead to misinterpretation and may not give an accurate indication of what the finished product might look like. Any misunderstandings at this level can lead to expensive reshoots later. The clean finished drawings would have to be prepared for the finished production in any case, and therefore need not be considered as unnecessary polished work at this stage. A good quality photocopier, with reduction ability, is the most useful asset at this stage of production.

In addition, a very useful and time-saving aid is to cut out a screen-shaped template with a clear open space within, to place over artwork which can then be photocopied to make up the storyboard. Making different sizes of templates to fit different parts of a piece of artwork can be useful, provided these can then be enlarged or reduced to comply with the size and layout of your storyboard.

If an animatic or Leica reel (the production of a filmed storyboard with voice-over, music/ sound effects etc.) is required initially as a presentation to clients, then the best quality finish should be attained to help sell the proposed work. Small, scruffy, unclear drawings are fine for the director as a reminder of what he or she has in his mind, but they do not always give a clear indication to others. Is not good communication one of the prime priorities of any production?

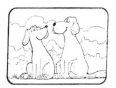

Scene of two dogs together.

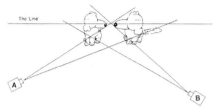

The camera position **A** gives us this view.

The camera position **B** gives us this view.

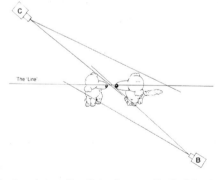

If the camera is placed at position **C**, i.e. "crosses the line" the dogs are no longer looking at each other and are placed incorrectly.

Fig. 1.7 Crossing the line.

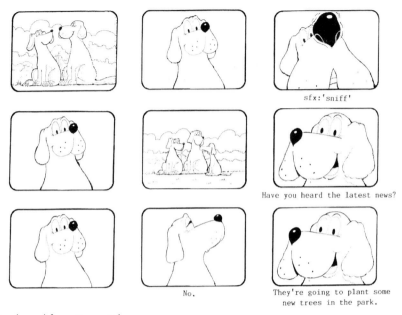

sfx:'sniff'

Have you heard the latest news?

No.

They're going to plant some
new trees in the park.

Fig. 1.8 Storyboard from *Furry Tales*.

Calibration

It is important, where possible, to keep the animation drawings as consistent as possible throughout the whole production. During the scanning and image processing (described in the next chapter) parameters need to be established. When a scanner is first connected to the computer for feeding the animation drawings into the system it needs calibrating. This establishes the pick-up sensitivity of the scanning process, i.e. the brightness or contrast between the black line and white background. Once this has been done, it should be unnecessary to keep

Fig. 1.9 Calibration.

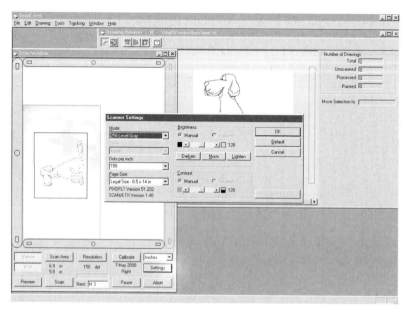

Fig. 1.10 Adjusting the settings in *ScanLevel*.

adjusting values during the production. Any subtle adjustments can be accommodated during the image processing stage later. It would therefore be sensible to keep to these figures to avoid having to keep changing the numerical values.

Fig. 1.11 Avoid gaps in the line where possible.

The software has been designed to allow for any extremes of line drawing, and that is one of the beauties of using such a system compared to the restricted contrast of using ink on cel acetate. However, it is necessary to be constantly aware that drawings with wide gaps in the line can cause added work later during the production process. This is not a problem, just extra work that should be avoided where possible. Experienced use of the software will guide the animator's view on this.

Line and Texture

While animating the character's lines, usually on white paper, it can also be useful to establish other lines and areas needed later for colouring and shading purposes during the ink and paint process (see Chapter 3). Any areas drawn up for body shadows or shading should be kept as simple black lines. These might be included within the character drawings or kept on different levels and scanned in separately as overlays or underlays. For example, a character with fur might require a form of cross-hatching. The texture drawing would then be better kept on separate levels so as not to interfere with the main outline of the body. Any special textures can be scanned in separately as a large area and stored, to be added to the character later using a system of mattes.

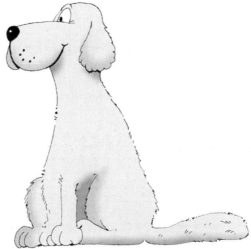

Fig. 1.12a Line drawing with shadow lines. **Fig. 1.12b** Finished coloured shadows.

Complex areas, which might need an alteration in opacity later, should be kept on a separate level, particularly if the opacity or colour needs to change during a scene. This might happen when a character walks near a light source, for instance. It is also useful to note that the computer can lose any or all outline drawings if necessary during the ink and paint process while still keeping the body of the character. If, for instance, a watercolour style was required the line can be removed later. Again, learning how to use the software and constant experience will help to establish the initial approach to the various aspects of drawing the characters. This is particularly true when considering colours and colouring effects for the characters later.

Fig. 1.13a Fur texture drawn separately. **Fig. 1.13b** The added texture overlaid.

There is no need to draw ground shadows for any characters. It is better to achieve this effect later during the final composition. Neither should any areas be filled in with black. This can be done during the *Ink and Paint* stage, because needless blacking can overload the work of the computer during *Image Processing*.

As long as the software carries blending abilities within *Ink and Paint* there is no need to consider airbrushing on the drawings at this stage. The computer should provide this facility.

If there are too many animated lines to draw and the work becomes too complicated, then it is better to colour code each of the animation lines, or colour the areas in between. Once coloured for inbetweening purposes all the parts will then stand clear and easy to read.

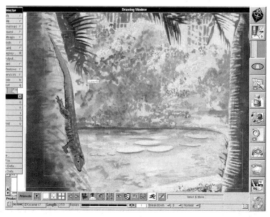

Fig. 1.14 Watercolour style from *Eyes of Karras*.

Fig. 1.15 Shadow created from the character drawing using silhouette and distortion filters.

All animation drawings must be clearly marked in the traditional way with scene numbers placed right of the centre punch hole and drawing numbers placed in the right-hand corner. As drawings are scanned into the computer they are automatically allocated numbers in order, but this can be redefined where necessary. Some animators prefer to work on odd numbers, allowing room for potential inbetweening later. The computer system should allow for this method or any other form of interpolation required.

Episode 2. Scene 1. A1

Fig. 1.16 Naming on bottom pegs.

- Any rough coloured tracing lines or underdrawing should be kept separately from the finished cleaned-up drawings for scanning. Such coloured roughs, no matter how lightly drawn, stand a chance of being picked up by the scanner, causing extra clean-up work later.

- Do not shade in any areas unless such a texture is required in the finished image.
- Do not black in areas of any drawings. This will cause unnecessary extra work for the *Analyser/Image Processor* application.
- Take a large piece of punched cel acetate and place it on the pegs in the scanner. Draw a line at the top of the sheet and at the bottom above the peg holes, to indicate the limits of the scanning area. You now have a guide to the limits of your drawing area.
- All traditional animation registration is usually based on the Oxberry standard punch peg holes and most of these computer systems align to this standard. The tradition amongst most animators is to keep the animation drawings on bottom pegs as the standard and the background on top pegs. This way, the hand is able to 'flip' through the drawings to test the animation movement free of any restrictions from the pegs. For the computer it is better to register everything together, either top or bottom. Any personal preference should not interfere with any of the processes.
- Remember to trace back to any master drawing each time you need to copy a drawing or part of it to avoid 'Chinese whispers'. Otherwise the drawings will wander and distort.

Numbering and Naming

Perhaps a little obvious, but a useful tip is to use the prefix of any numbering of animation drawings as a code. 'E' might be always allocated for eyes, 'M' for mouths, 'W' for walk cycles, etc. This becomes useful for immediate recognition during doping later. It is good practice to keep to a consistent number code in your memory that can be instantly recalled when doping lip-sync.

Paper

Just as in traditional animation, the two main sizes of paper for drawing on are 12-inch and 15-inch field. The regular industry suppliers will sell you the correct type of paper: tough, thin, see-through on a lightbox, with a smooth finish. However, photocopy paper, available as A4 or A3, is at least half the price or less, and easily purchased. It is not as transparent and inks tend to bleed a little too much for small illustrations, but it is well worth consideration where budget limitations are a matter of concern. Of course, there is no longer a need for purchasing expensive boxes of cel acetate or panning cels when using computer animation.

Drawing Tips

It is always important to remember that, in general, animation drawings need to exaggerate movement. Like live stage acting where the performer has to reach the audience at the back of the theatre, the cartoon character has to be larger than life to express the mood and drama of a scene. All animators should have an instinctive awareness of nature's movement, drama, moods and body language. Watch a mime-artist's performance to witness exaggerated expression and movement. A clown at a circus will make extravagant gestures to express himself clearly. In dance, the head is often held high, the arms outstretched, so that the performer is making the most of the body area, the largest possible silhouette to be seen against the

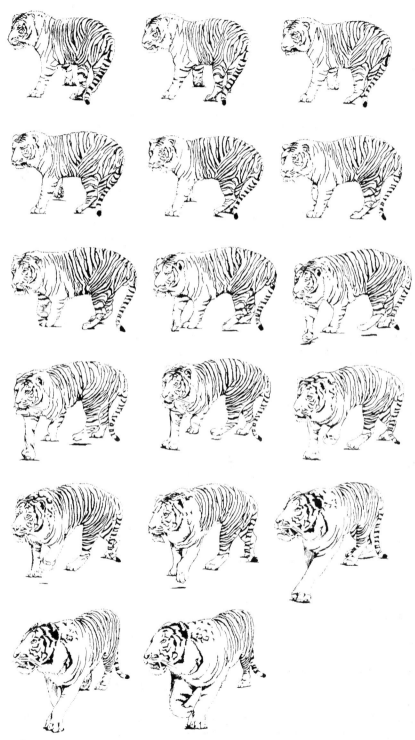

Fig. 1.17 Walking tiger sequence from *Eyes of Karras*.

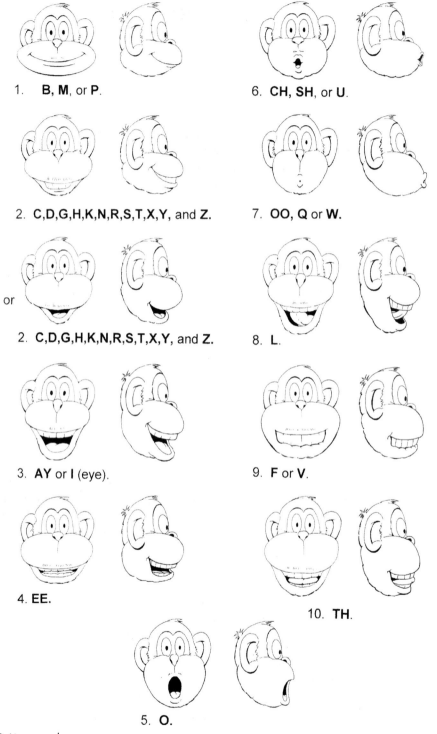

1. **B, M**, or **P**.

2. **C,D,G,H,K,N,R,S,T,X,Y**, and **Z**.

or

2. **C,D,G,H,K,N,R,S,T,X,Y**, and **Z**.

3. **AY** or **I** (eye).

4. **EE**.

5. **O**.

6. **CH, SH**, or **U**.

7. **OO, Q** or **W**.

8. **L**.

9. **F** or **V**.

10. **TH**.

Fig. 1.18 Lip-sync phonemes.

Fig. 1.19 Exaggerated aspect of dog sniffing from *Furry Tales*.

background. Many of the Walt Disney animators were encouraged to study nature and trained to use a mirror where they could exaggerate facial expressions to draw from. During the production of *Bambi* a real baby deer was introduced into the studio to be used as a life study model. All this attention to detail and study helped to establish a level of quality of animation that is still apparent in modern productions.

Today, artists have the benefit of watching more than enough animal programmes on television to get sufficient material for study. For example, in nature, during a display of animal or human confrontation, we might witness a demonstration of **displaced aggression**. Really, both parties want to hit each other, but instead they peck at something nearby, paw at the ground, punch their fists into their hands, bang the table, stamp their feet, etc.

Fig. 1.20 Displaced aggression.

Before any object moves off from a static position there is always a prior movement in the opposite direction, a withdrawal backwards, an **anticipation movement**. This type of movement is very apparent when a blackbird or robin, for instance, is just about to fly off. It will duck a few times before it finally goes. This is a very good example of anticipation movement.

Fig. 1.21 Anticipation movement of Robin before flying off.

When an object travelling in one direction impacts against the surface of something else, the object will **squash**. Similarly, while it is moving, to exaggerate speed and force, it may need to **stretch**. And having hit a surface the momentum may force part of that object to continue its directional movement, causing **follow through**, a delayed secondary movement or **overlapping action**.

Fig. 1.22 Squash.

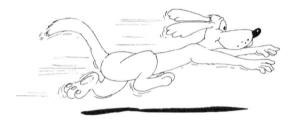

Fig. 1.23 Stretch.

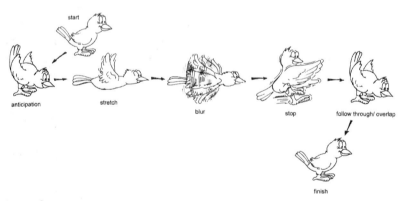

Fig. 1.24 Forces of motion.

The **wave rhythm** is applied when animating water, smoke, a flag or foliage in the wind etc. or even animal and human movement. This law of nature should be used many times, so maintain your awareness of it. When doping out this animation for several similar objects avoid repeating the movement in unison. Try to 'ring the changes' to make the movement seem more natural.

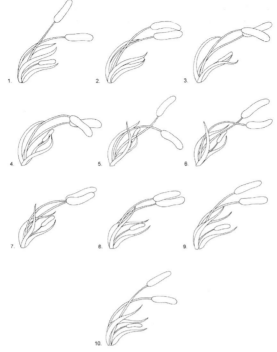

Fig. 1.25 Wave cycle 1 to 10 and back to 1, etc.

Generally, a movement in one direction creates a reaction in the opposite direction. Like a pendulum, a swing or thrust one way causes the reaction of an opposite movement the other way. Make use of this law when drawing walk cycles. Again, if there are two or more characters walking together, break the step by doping them out of sync with each other for a more natural movement.

All cycles should be drawn on the spot, in the centre of frame. They can then be manipulated across the screen later when they are put together with the full scene in *Composition*.

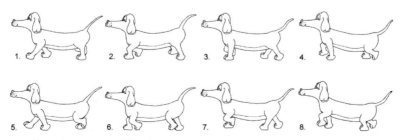

Fig. 1.26 Dog walk cycle 1 to 8 and back to 1, etc.

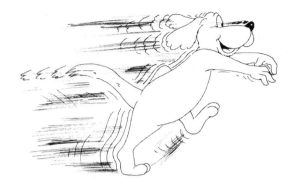

Fig. 1.27 Swish lines.

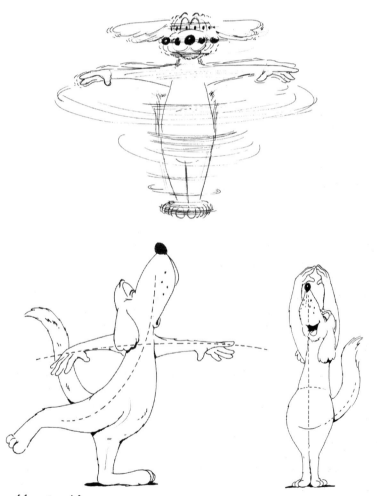

Fig. 1.28 'Lines of force' and free movement.

In live-action filming, sometimes the movement across the frame is so quick that the image is blurred. With animation, just in the same way, it is necessary to simulate the same effect when the object moves across the frame beyond a certain speed. This is created by **swish**, drawn lines, airbrushing or painted brush strokes to produce a similar result. As a rough, general rule, you can estimate that if a character moves in each frame more than half an inch or so, on a 15-inch field, then straight drawings would start to strobe.

All animation drawings should be directed from the elbow and not from the hand. If our initial key drawing roughs are drawn too tightly with our hands held rigid and our noses buried in the lightbox, the results will inevitably appear awkward and cumbersome. All drawing comes from the head and not from the hand so, for smooth movement, a certain attitude of mind should be adopted for successful results. Stand back and consider movement, pose, gestures, proportions, lines of thrust and rhythm when producing your first animation key drawings.

All these rules must be applied to help create weight and strength to the animation. After all, we are using a few static drawings to create dramatic illusion artificially.

Enlarged Drawings

If the character drawings do not have to be registered to any matchline in the background, and are therefore free of any size restriction, it is obviously easier if they are drawn large and reduced in the final composition: not something that can be done using traditional animation methods and rostrum camera. The drawings can therefore carry a lot more information, blown up, and be composed of a more sophisticated content. The correct resolution for scanning in drawings should be maintained at the right level, to give high quality definition when outputting without unnecessarily overloading the system. The DPI values for scanning in drawings for video should really be kept at 150 or above. Below 150 DPI the image may show the composite of pixels. Above that number and the computer is working harder than necessary and will not benefit the finished result. At that value the drawings can be enlarged or reduced during the final composition without much line interference. For film the values need to be higher, but the computer software should advise accordingly.

Try to avoid matchlines where possible. Sometimes the registration can be a little inaccurate, especially on close-up camera. It is therefore better to overdraw the part of the character and load it as an underlay. Just make sure of the correct position of levels in the final scene composition. These systems are happy to work with any amount of levels of drawings, unlike the limitations of traditional cel drawings under rostrum camera. It is also possible to float a separate part of the background over the character drawings to avoid matchline problems. This extra portion of background can be created as a matte, copied or redrawn in many different ways. If a matchline needs to be used then it is better drawn black and coloured to match the background later, if necessary.

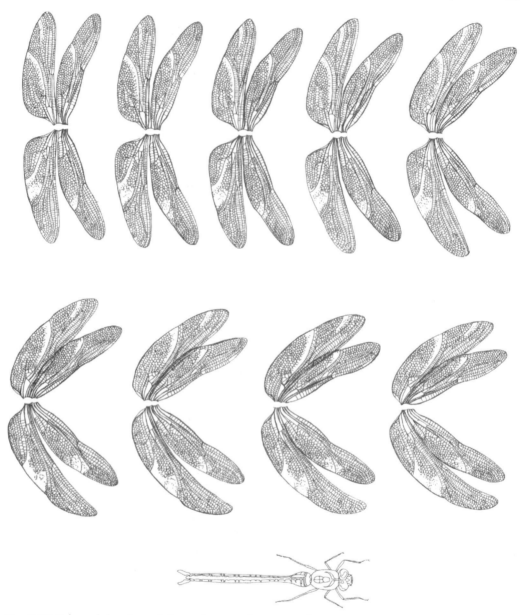

Fig. 1.29 Enlarged drawings of dragonfly wings from *Eyes of Karras*.

Scanning

As long as the scanner is calibrated correctly, using a pegbar, all drawings will be registered together provided they are placed properly. The orientation of the paper should be related to the pegbar in the scanner before any scanning takes place. Some scanners and computer systems offer an automatic feeding facility, but registration can be a little inaccurate. It is always better

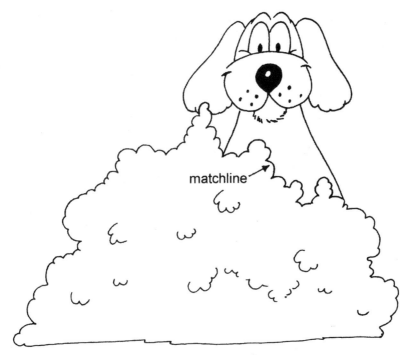

Fig. 1.30 Dog drawing with matchline over bush background.

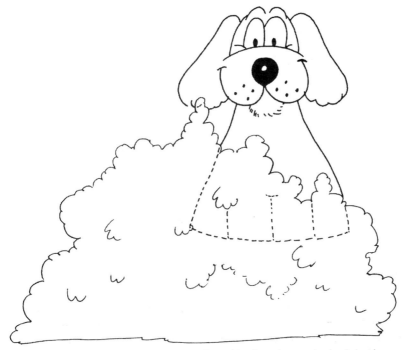

Fig. 1.31 Dog drawing without matchline and overdrawn body to lay under bush background level.

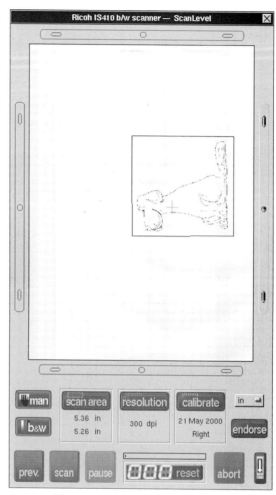

Fig. 1.32 Scanning area kept as close as possible to animation.

manually to feed in the drawings. It is also better to restrict the area scanned to as close to the drawing as possible to avoid any later cleaning and tidying with *Ink and Paint*. When drawings alter in position and size on the paper during the normal course of any animation, it then becomes necessary to alter the scanning area accordingly during manual scanning. This might seem a tedious occupation, but does reduce workload in *Ink and Paint*. It also helps to keep the drawings as clean as possible, particularly free of any irritating eraser debris. For normal animation drawings registered to a conventional 15-inch academy field chart (sometimes known as a 'graticule') the scanning should be done on an A3 size machine. The recommended professional A3 scanners are made by Ricoh. Not cheap, but they do last and, considering the constant use expected from them, the machines need to be of this high quality.

Keep the artwork as flat as possible when you are scanning. Use the correct approximate weight of paper and avoid thick card. Any artwork that is uneven may cast a shadow across the image when it is being scanned, and cause problems for the subsequent processes.

Fig. 1.33 15-inch graticule.

Fig. 1.34 12-inch graticule.

Filing

As with all computer systems, as soon as any information is loaded in for the first time a folder has to be set up. Within the folder a selection of files will keep all the different objects neatly stored and saved, just as you would keep all your papers stored away in a filing cabinet in the office.

When setting up the production within the computer at commencement it is essential to organise a practical path for the files. A suggested directory structure could start with *Productions*. The next files could be split into *Scenes* and *Colourmodels*, then *Levels*, *Backgrounds* and *Output*. It is within *Levels* that the animation drawings should be placed. It is not only wise to keep with a recognised file structure for the sake of the production studio, it is also sensible for discussing information over the telephone with technical computer support groups.

A Suggested Directory Structure

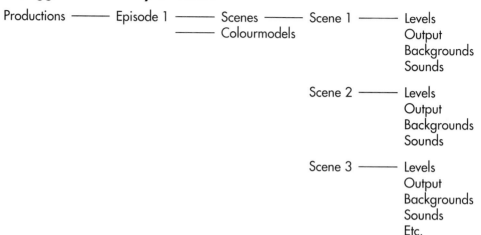

It is also a good idea to create a *General Graphics* and an *SFX* folder. There are many bits of backgrounds, graphic images and drawings etc. that you might wish to store for further use in future productions. While you may very well have to destroy many of your productions to leave room on the hard disk once they are completed and **backed up** on tape or disk, it is useful to hold these odd bits and pieces for future use. Again, any animated special effects such as rain, snow, explosions, smoke, water, etc. should be retained in the *SFX* folder.

Fig. 1.35 Snow cycle 1 to 4 and back to 1, etc.

Fig. 1.36 Rain cycle 1 to 4 and back to 1, etc.

Vectors

Some animation computer systems use a completely different way of producing the drawings by the vector system. Drawings are created inside the computer and not on paper. Outlines of the character or paths are drawn using a choice of pens or pencils from a toolkit. The outlines are the 'skeleton' of the character employing **knots** at intervals in the lines. Once the basic shape of

Fig. 1.37 Explosion showing selected drawings 2, 3, 4, 6, 7, 8, 13, 20, 28 from a run of 1 to 34 on doubles. Notice how the clouds rise as they disappear.

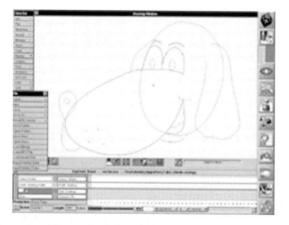

Fig. 1.38 Vector drawing using *Director* in Animo 1.7.

the object has been drawn it can be manipulated simply by changing the position of the knots or by changing the gradient of the path either side of a knot. This is done by altering a **tangent** associated with that particular knot.

The benefit of this system is that once the character has been drawn, like 3D animation, it can be animated around the screen by manipulation rather than by reproducing many more drawings.

In its original conception Animo was designed using vectors but later adapted to the more traditional style of working that most animators are familiar with. Even so, the Animo system has still kept the use of paths, knots and tangents in its final composition application, *Director*, to manipulate a character around the scene, along a pliable pathway, other than in a straight line, and also for the use of drawing mattes.

Effects animation such as snow, rain, wind, fire etc. are produced very effectively using the vector systems, but can also be drawn in the usual way on paper as cycles and manipulated in the final composition.

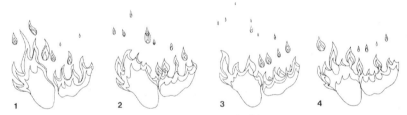

Fig. 1.39 Simple fire cycle 1 to 4 and back to 1, etc. on doubles.

Replay or Line-tester

Once the drawings have been scanned into the system always use the 'replay' device to see a line test of the animation. It is essential to check the material at this stage before any further processing is done. Inevitably, with the best will in the world, mistakes are made and will show up, especially on character drawings with complex patterns and lines, etc.

To summarise:

- Never spend the day sitting at the lightbox. Get up and stand back from your drawings to obtain a fair appraisal of your work. If necessary, view your work in a mirror to observe it for the first time as others see it. You may be surprised at what you see.
- Keep all drawings clean.
- Draw all shadow, tonal shade, textured areas on separate paper sheets.
- Avoid matchlines where possible. Keep any moving parts as overdrawn to lie beneath the body of the character.

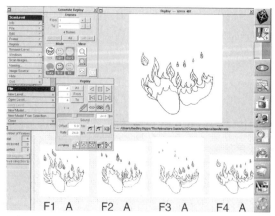

Fig. 1.40 Animo's *Replay.*

- Make the drawings larger than needed, where they can be reduced for the final scene. Also note that any image can be flipped, E–W or N–S, rotated, stretched, enlarged or reduced to avoid any unnecessary drawing.
- Once you are working within the computer, always remember to save. All computers crash, some more than others, so SAVE!

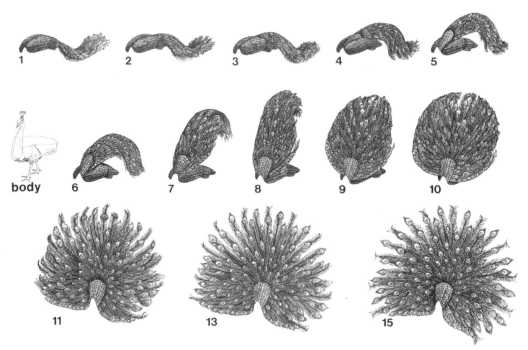

Fig. 1.41 Enlarged drawings of peacock from *Eyes of Karras.*

chapter 2

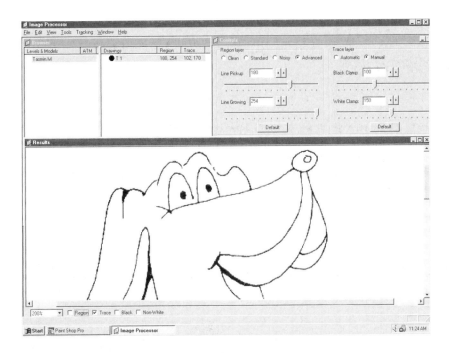

image processing

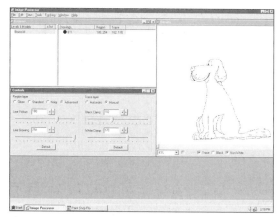

Fig. 2.1 *Image Processor* from Animo 3.

The purpose of this process might seem obscure at first, but it has two important functions and is vital for the workings within the computer. No further development of the artwork can be achieved without firstly completing this stage. Two defining factors require to be established at this stage to complete the process for the animation drawings. The computer needs firstly to set the quality of the animation drawing lines, and secondly to create boundary areas or maps where the infill of colour can be placed at a later stage. These are represented by the *Trace Layer* and the *Region Boundary* lines or *Region Layer*. When a drawing is scanned into the system it

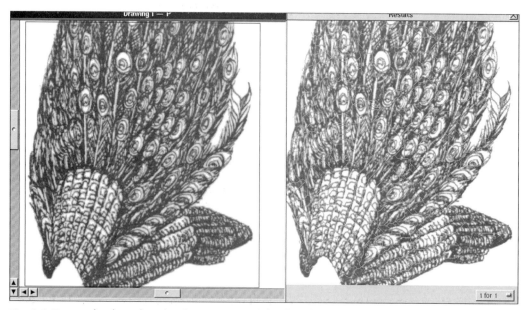

Fig. 2.2 Too much ink work in the drawing can overload and slow down the system.

is stored as a bitmap, and called the *Trace Layer*. The application of the *Image Processor* examines the bitmap and adds some extra layers to each drawing, the *Region Layer, Ink Layer* and *Paint Layer*. If any areas are filled in black during the initial drawing it is in the *Region Layer* where this practice unfortunately causes the application to overload with needless extra work.

The Trace Layer

The *Trace Layer* influences the sensitivity of the drawn line. The black values (or Clamps as they are sometimes called) control the parts of the image towards black, and the white values control the parts of the drawing to be converted more towards white. If the animation drawings are the conventional, simple black and white contrast ones then the black value should be approximately 100 and the white value approximately 150. Always keep a difference of at least 40 between the two values. Giving the drawings this value during this process will clean the drawings and enable smudges and dirt to be ignored. If, however, the drawings are of a softer type, where a subtlety of pencilling and grey tones are needed, then the black value should be reduced to a number nearer 0 and the white value should be kept at the other extreme towards 250. These values will keep the grey tones and softer pencil lines, but will also keep any smudges or unwanted marks. Therefore the animator has to pay more attention to keeping the artwork clean at these values. Choose the lightest area of the artwork when adjusting the values.

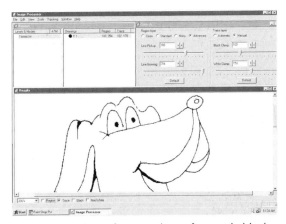

Fig. 2.3 The *Trace Layer* is given the values of 100 and 150 for simple black and white contrast drawings.

The application dealing with this process should allow the operator to see the effects of changing these values as an aid to choosing the quality of line needed.

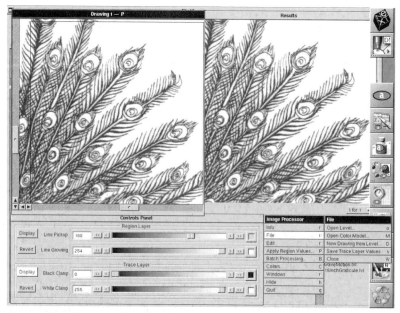

Fig. 2.4 The *Trace* values here are placed at the extremes of 0 to 250 to allow for all the soft drawing to be included in the finished image.

The Region Layer

The *Region Layer* does not affect the original drawing at all. It is purely a requirement of the system to establish the complexity of mapping within the drawing for defining the areas to be painted later. Mapping lines are coloured red and appear over the tracer lines. An average balance of values could give the line pick-up at 180 and the line growing at 254. For convenience the computer allows the operator to see either the *Region* or the *Tracer Layer* separately or together.

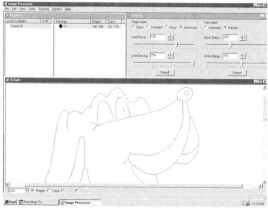

Fig. 2.5 *Region* lines for a simple drawing.

Given that the style of the animation does not change during a production most of these systems use a *Batch processor* whereby collections of files are grouped and given the black and white values that remain consistent throughout the production and then applied. This batch processing does help to speed up the entire process.

If any part of a character is to be given a texture or special effect then a separate matte drawing should be prepared for that area of the image. The matte can then be scanned into the system and processed in *Auto tone matting*. The matte is automatically given a matte colour, usually black, and saves the need for painting later.

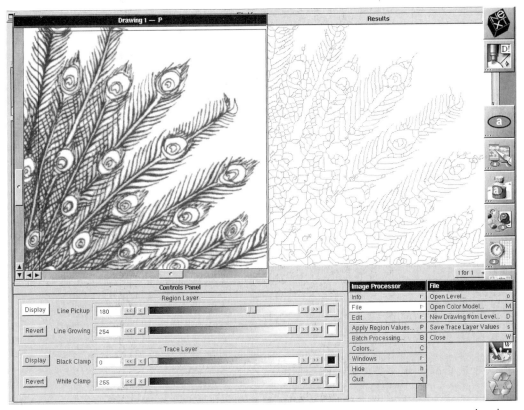

Fig. 2.6 This overworked drawing shows the complexity of the *Region Layer*, causing stress within the system.

Once the *Image Processor* has performed its duties with the drawings and has been saved, the next stage of production is the *Ink and Paint*. It is worth noting, however, that if at any time the drawings need to be referred back to the *Image Processor* for reprocessing anew and the *Region Layer* is adjusted, any ink and colouring work completed in *Ink and Paint* will be completely lost. Usually there is no reason for reprocessing any work, but because life is never perfect problems may occur occasionally. One bug within Animo 1.7, not mentioned in the

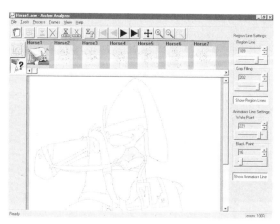

Fig. 2.7 Archer's *Analyzer.*

manual, may surface at times. This is thrown up as a 'Type Error'. This bug was particular to 1.7 and earlier versions, but has been eradicated in subsequent releases.

- In Animo 1.7 repair a 'Type Error' by firstly referring to the Desktop and, in the file viewer, clicking *Open folder.* Change the drawing file *'lin'* or *'fil'* name to *'badlin'* or *'badfil'*, whichever is causing the problem. Then reload the drawing file back into the *Image Processor* and repair the file by reprocessing it.
- Use this opportunity to clean up any drawings with smudges as for as possible by adjusting the *Trace Layer.*
- *Trace Layer* values can be adjusted at any time during production, even when the work has been through *Ink and Paint,* but any adjustment to the *Region Layer* will destroy ink and colouring work.

chapter 3

ink and paint

Once the character drawings have been processed in the *Image Processor* application then they can be coloured in *Ink and Paint*. (Note that no drawing can be coloured until it has been scanned into a level and been through the *Image Processor*.)

One of the most useful assets of ink and paint systems is the benefit of colour control throughout the production. Once a character is allocated a range of colours, the staff of painters cannot alter them but must follow the instructions within the system guided by a predetermined colourmodel.

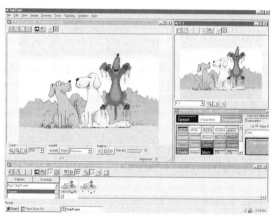

Fig. 3.1 Animo's *Colourmodel*.

There are two parts within *Ink and Paint* to be considered: firstly the *colourmodel*, and secondly the inking and painting facility. The **colourmodel** dictates the choice of colours, degree of blending, arrangement, and placement of colours. This sets up a control of colours for the ink and painting. Each colour is attributed a 'painting only' or 'ink or painting only' use. It means that while teams of artists apply the colours to the character drawings in the second part, they must, and can only, follow the colours dictated by the colourmodel. Any alterations that do become necessary at any time to alter the colouring of the character have then to be applied within the colourmodel and may only be accessed by a systems administrator. This is the way the system ensures that the colours and blends of the character remain constant throughout the production.

There is the particular advantage here that if at any stage of production the colour within a character or the blending needs to be altered it can be accessed through the colourmodel and changed. Any change is then automatically effected throughout, even to the final stage of production within *Director/Compositor/XSheet*.

Each colourmodel representing each character also contains a **palette**, the range of identified colours that define skin tones, clothing, etc. It is possible to add more palettes with the colourmodel to create a different range of colours for the character. If, for instance, the character

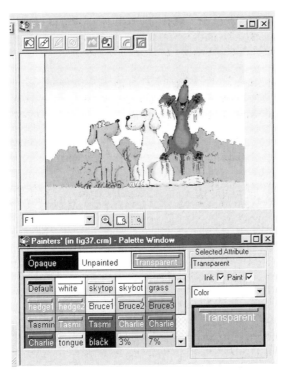

Fig. 3.2 *Colourmodel* showing the different colour inkwells.

Fig. 3.3 Both *Ink* and *Paint* attributes are ticked.

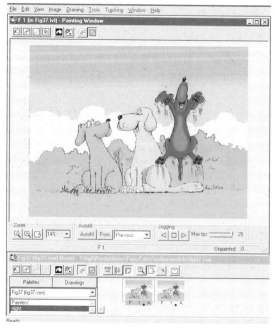

Fig. 3.4 The same scene using a different palette for night scene.

appears in a night scene or under water, or in some scenario where the whole appearance is changed by the environment, a second palette may be introduced and a whole file of animated drawings can be immediately updated to the new range of colours. The old colour ranges are not lost. They can be retrieved simply by replacing the original palette.

This can be particularly useful when a character needs to change colour within a scene. For example, the character might walk under a street lamp at night and change from night colours to normal palette.

A palette containing a whole range of colours for the character can be given an overall tone or tint for such a scene by loading it into *ColourCorrector*. There, the palette can be given any value

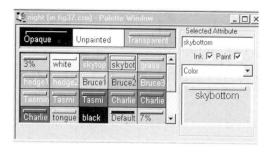

Fig. 3.5 'Night' palette.

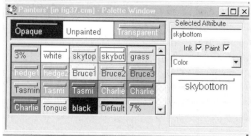

Fig. 3.6 Normal *painters* palette.

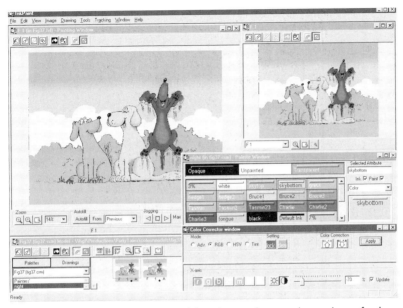

Fig. 3.7 *ColourCorrector* used in the *Colourmodel* to change the complete palette of colours in one simple action.

of colour, hue, and brilliance using RGB or HSV and saved for later use. The changes will affect the whole palette and all the colours within it. To change any individual colour within an inkwell must be done in the colourmodel.

Any number of palettes can be created to change the colour of the character drawings subtly without the need for repainting any of the drawings.

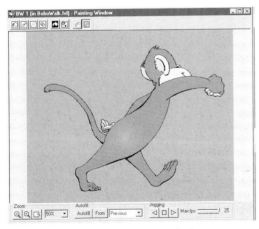

Fig. 3.8 Character against the default transparent grey.

Fig. 3.9 Character with background added.

When choosing the range of colours in the colourmodel it is advisable to load in the background artwork behind the character drawing. It is surprising how much the background can affect the balance of colours within the drawing. When the drawing is left against a white or plain background the selection of tones and hues can be wildly off balance.

If ever necessary, it is also possible to grab colours from the background and place them within the palette. It may be for some reason or other that the character has to match a colour accurately within the background and this can be achieved in this way. If you do need to draw a matchline which also matches the colour of that part of the background then the *Magnifying glass* tool is able to grab the particular colour and copy it identically.

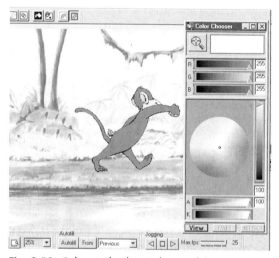

Fig. 3.10 *Colour Wheel* in *Colourmodel.*

Fig. 3.11 *Magnifying glass* tool from *Colour Wheel.*

Of course, the actual empty space around the character drawing is given a transparency and can be coloured in anything, but for convenience sake is usually given a mid grey.

If for any reason you need to create similar greys for painting the character make sure you are aware of the potential mistake of then using transparency grey for a part of the character or painting the background a solid colour. The mistake will not be apparent until the level is loaded into the final composition. You can easily change the colour for transparency by dropping a new choice of colour into its well on the palette.

On a big production where potential mistakes like that are difficult to monitor it might be advisable to load any subtle tones with bold contrasting colours and make any last minute adjustments in the colourmodel once all the levels have been painted.

Colours are selected from a *colour wheel* or *colour editor* and placed into inkwells within the palette. On the colour wheel RGB values are adjusted by varying Red, Green and Blue. HSV alters the Hue, Saturation and brightness (or Value) component.

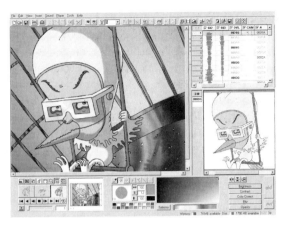

Fig. 3.12 CTP's colouring facility.

The *Magnifying glass* tool grabs colours from another source, say for example a background, and loads them into the inkwells. That way, any colour in the character drawing can be matched to the background as previously explained.

Because each drawing in a level consists of two layers, the *Trace Layer* and the *Paint Layer*, lines in the drawing can be accessed, coloured and treated in various ways, independent of the paint regions. The default colour of the line is usually black, but lines can be coloured, erased, thickened or even blended. A watercolour or flat paint effect can be achieved by erasing the lines of the drawing by using 'transparency' with the appropriate tool. A blended line would give the appearance of a blur. However, it is worth noting at this point that a blurred effect might be better created in the final composition, but experience with these computer systems will help the operator decide where and how these effects can be best applied.

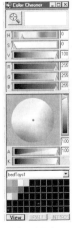

Fig. 3.13 *Colour Wheel, Colour Chooser* or *Colour Editor.*

Fig. 3.14 Default black line.

Fig. 3.15 Most of the black lines are erased.

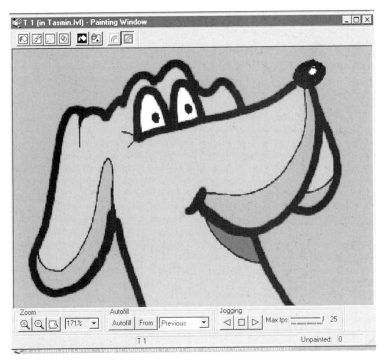

Fig. 3.16 The black line can be thickened.

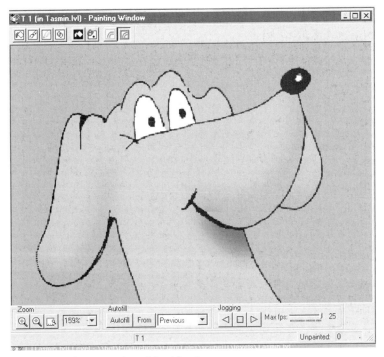

Fig. 3.17 Some lines have been employed for blending.

The drawings can be displayed in many different options showing the current mode as 'paint mode', 'unpainted areas', 'see-thru mode', 'line', or 'final stage'. 'See-thru' is useful when a repair or additional line needs to be applied to the next drawing, referring to the previous drawing as a guide. In Toonz this feature is known as *Onion Skin* modifier. This allows you to pick a colour from the previous image and apply it to the current one. The colour is picked when clicking with the left mouse button and applied when releasing it; while keeping the button pressed you can move the cursor in order to fill an area not overlapping the painted area under the skin.

Fig. 3.18 Paint mode.

Fig. 3.19 Unpainted areas.

Fig. 3.21 Line only.

Fig. 3.20 See-thru mode.

Fig. 3.22 Final stage.

Any area or part of the drawing can be enlarged or reduced using panning and zooming facilities.

(**Tip**, for Animo users: *Alt Gr* or middle mouse selects a pan tool. *Alt* selects the gap filler. *Shift* selects the copy paint 'dropper'. *Ctrl* selects the zoom tool.)

Fig. 3.23 Animo's *Panning* tool.

Fig. 3.24 Animo's *Zoom* tool.

There are many tools available within the painting application. Many have been designed especially to help save time and work and are extremely useful:

● **Markup** tools allow for each colour region to be labelled in the colourmodel.

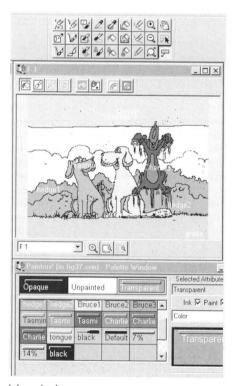

Fig. 3.25 Animo's *Colourmodel* marked up.

● **Inking** tools are used to ink the drawing lines.

Fig. 3.26 Animo's *Ink* tool.

● **Painting** tools paint the regions in the drawing in the paint layer.

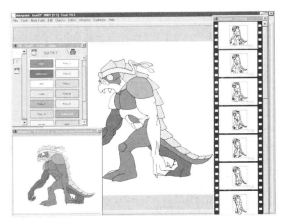

Fig. 3.27 Toonz' *Inknpaint*.

● **Region modification** tools allow for the region boundary lines to be altered or repaired.

Fig. 3.28 Animo's *Region line fix* tool.

● **Tracing** tools can add lines to a drawing.

Fig. 3.29 Animo's *Trace Brush*.

● **Zooming** and **panning** tools enable close inspection of the drawings.

Fig. 3.30 Animo's *InkPaint* showing an enlarged area of drawing within the painting window. If necessary, any amount of further zooming can be achieved.

Most systems include an *Autofill*. This feature takes the next character drawing and fills in most of the unpainted areas with, hopefully, the correct colours. The process usually refers to the previously completed painted drawing if the drawings do not differ. But it always requires a little

Fig. 3.31 Animo's *Autofill*.

tidying up and checking to make sure the system has not applied the wrong colour somewhere on the character. If the variance between drawings is too extreme then *Autofill* is limited and can cause so much mending that its use is not warranted.

(**Tip**: When the correct colourmodel is loaded into a reference window click on any colour area to load the present inkwell with that colour for immediate painting use. This is especially useful if the painter is not sure which colour should be applied to paint a particular area on the drawing.)

Apart from the most obvious tools the operator would expect to find in most painting systems there is one which is most useful. It is a *Paint lock*. If there are certain chosen areas of colour, or lines, still left to be painted on a range of drawings, the *Paint lock* can be dragged over the character, thereby painting in the remaining areas that need the colour without affecting any previous work.

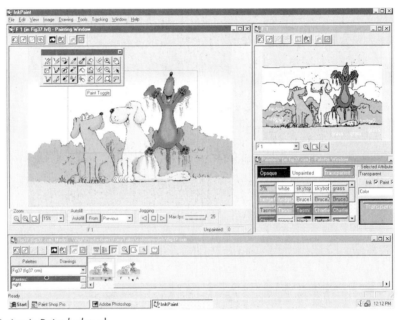

Fig. 3.32 Animo's *Paint lock* tool.

Each drawing in a level wears a symbol showing its state of progress through scanning, processing and to final stage of *Ink and Paint* completion. Each drawing has to be 100 per cent complete before the symbol alters to show that the character drawing is totally painted.

A quick replay can be accessed at any stage during *Ink and Paint*, particularly useful at the final stage of painting to check that all areas are complete and nothing has been left unpainted.

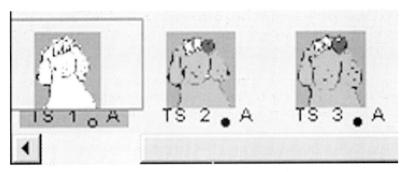

Fig. 3.33 Animo's progress symbol. The first picture is unpainted and shows the symbol as white. Drawings 2 and 3 are completely painted and show the symbol in black.

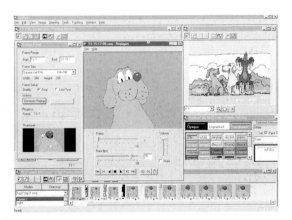

Fig. 3.34 Animo's *Replayer*.

Fig. 3.35 Linker's Animation Stand *Ink and Paint* facility on a Macintosh computer.

- By clicking on the colourmodel in the painting window the colour is automatically selected in the painting inkwell.
- When applying *Autofill* it is possible to select the source drawing by highlighting a choice and clicking on *From*.
- A very useful tool is the ink or *Paint lock*. It means that anything that has already been painted will not be affected by any new changes such as a sweep of the cursor over the whole area.
- *Undo* will correct the last ink or paint operation up to 20 of the previous actions (Ctrl + Z, Animo shortcut; Ctrl + U, Toonz shortcut). Many systems offer a *Redo* as well.

chapter 4

backgrounds

Backgrounds are usually handpainted on A3 white cartridge or watercolour paper of about 150–180 gsm. Anything thicker may cause problems with shadows when scanning. Of course, we all have our own style and ways of working, and many other options may be preferred, but this is a general guide.

The most useful aid to the background artist is a photocopier that can enlarge and reduce the size of any image. If necessary, a collage of photocopied images or designs can be pasted together and stuck to the back of a piece of cartridge paper. When placed over a lightbox the outline and drawing of the objects in the background can be traced through. This is another reason to keep the thickness of the paper to 150 gsm or less. Printed images or pages from books can also be scanned in as backgrounds provided, of course, there is no copyright obstacle. Any texture from the printing process of the book can be lost if the final image is output to video, but film might be too sensitive to allow for this practice.

Fig. 4.1 Background from *NunsDrakka's Child* painted on cartridge using oil paints.

The usual way of preparing cartridge paper for painting is to wet and stretch it beforehand. However, most studios are under stress with tight schedules and there may not be time enough for such preparation. If you are using black and coloured inks for painting then pressing the completed artwork on the back of the cartridge paper with a domestic iron will flatten the image well enough. Another method might employ leaving artwork to press under a pile of books over night, but whatever methods are employed the final illustration must be flat, otherwise the picture will not scan properly and shadows will cause uneven areas in the final background.

For my own preference, I use oil paints 'watered' down with white spirit. This medium is the most versatile and does not cause the paper to buckle as much. Of course, sometimes the paint does take a while longer to dry, but it is worth waiting that extra day or two. Many inks are not colourfast, which may not matter for their immediate purpose, but if the artwork is to be framed and hung on a wall afterwards they will fade in time. Acrylic inks and paints do not fade, and nor do oil paints or guache.

Provided any animation drawings are registered to the background artwork with the normal use of pegbars there should not be much of a problem with registration, but no system is perfect. Any slight adjustments can be sorted out during the last stage of composition without too much difficulty.

Fig. 4.2 Black ink on cartridge and acrylic inks used for the airbrushing.

A3 colour scanners are usually too expensive for most studios and therefore more often an A4 colour scanner is employed to scan previously prepared artwork into the system. To allow for reasonably large pieces of artwork to be processed the common practice is to scan in sections of the background and then splice them together. These are then saved in TIFF, TILED or TGA formats. TIFF files are recognised by most computer systems but do not keep their registration. However, once loaded into the final composition they can be easy manipulated into position.

If registration is essential, i.e. a character is registered to a background, then it should be saved in TILED format. If the file has to be exported into a third party application for further processing then it needs to be saved as a TIFF or TGA.

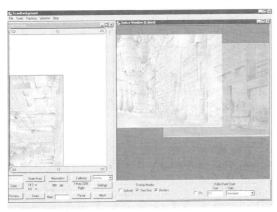

Fig. 4.3 Inked and airbrushed artwork scanned in two parts and ready for splicing together in Animo.

Sometimes a character needs to pass through a doorway or behind some part of the background. There are then three options in which an overlay can be created. The first is to draw a matte line around the object and thereby create a matte of the overlay. This is done in the final composition application (see Chapter 5). This method can be a little complicated and cumbersome. A second choice might be to create a second piece of original artwork and scan this in as an overlay. Sometimes this technique might work well, but registration could be a problem and you might also discover difficulties in matching colour, texture, etc. The third and preferred option is simply to copy the original TIFF file, rename it as an overlay, and load it into a third party application such as PhotoShop. Parts of the background that are unwanted can be removed, leaving a transparent area to create the completed overlay. You can then be assured that colours, textures and registration remain perfect. The third option may also be the quickest and less fraught. The files do take up a lot of memory on the hard disk and it might be necessary to be aware of this fact when choosing the correct DPI. For video and television, using 200 DPI should be sufficient. Obviously, the size of the image should be restricted to the bare minimum.

Fig. 4.4 Background and separate overlay scanned into the computer.

Fig. 4.5 Overlay laid over the background as it might appear in the finished film.

If any artwork is prepared on cel acetate, scanning should not be a problem. Fortunately, the scanning process does not seem to pick up any reflections, provided the lid of the scanner remains firmly closed.

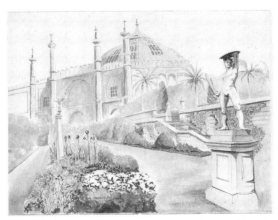

Fig. 4.6 Background from *Eyes of Karras* using pencil on cartridge and handpainted colouring inks.

If the style of the artwork background is fairly flat in colour, and particularly devoid of texture, it is always better to draw the image as usual on animation paper, scan it into the computer as you would an animation drawing and treat and colour it in the normal way. Having created a colourmodel for this drawing in the customary way it can then be saved as a TIFF file, or kept as a level. The memory required for this operation requires far fewer bytes than artwork prepared beforehand and scanned into the system. Sometimes, the large, flat, white or coloured areas of a background are best created separately as a level using ink and paint, or by other means in the final composition. White in the prepared artwork does not always scan in correctly as a flat area and contracts a colour bias. It is easier to scan these

Fig. 4.7 Background drawn in black on animation paper, scanned into the computer as a level and then painted in *Ink and Paint* using flat colours and blends, and saved as a TIFF.

backgrounds in as an overlay, leaving a transparent area, and then add your coloured background underneath.

For the common practice of using a repeat background for a panning scene, two backgrounds can be scanned in with each end matching the other for placing together in the final composition. It is also very easy for most computer systems to flip any image. This is another useful way of avoiding the creation of enormous lengths of artwork to cover for a panning background.

Fig. 4.8 Two pieces of panning foreground plus a third part flipped as a copy from the second.

Fig. 4.9 The combined parts making up the completed repeat panner.

Many years ago a famous animator, who shall remain anonymous, made the fatal mistake of drawing in the sun on a repeat panning background. Of course, the obvious result was very amusing and has been held as a classic item of animation gossip ever since. There is no excuse for making a similar faux pas with these computer systems, when a quick replay can be run at any stage during production.

Vertical panning backgrounds were always a nightmare when using conventional camera techniques together with animated cels, and made even worse when other pegbars had to pan as

Fig. 4.10 Background used for a vertical pan.

well. None of these problems need concern the animator using these computer systems. There are no such worries. Any long panning background can be loaded in sections as explained already, and turned on its side in the final composition to pan vertically or at any angle required.

If a character is walking or moving along a panning background, with animated drawings filmed on doubles, i.e. one drawing for every two frames, then the background should be panned at a corresponding speed. In some situations the background should also be panned on doubles to avoid the character slipping. Trial and error is the only option to adopt in these cases, by testing and replaying the results.

For most work, the use of a third party, plug-in package, such as Adobe PhotoShop, PaintShopPro or CorelDraw, with **scanning background** applications, is strongly recommended (see Chapter 7). Sometimes little corrections are needed in the background artwork, or whole areas might need to be cut out or pasted over. If anyone is still using a Unix-based software system such as OpenStep or NextStep, I would highly recommend adding Wetpaint to your system. This is an excellent graphics package. Sadly, most of this software has become redundant and has been taken over by Apple, but it is now available free on the Internet and can be easily downloaded.

Background artwork can also be prepared using these design packages to draw 2D or even 3D images.

PhotoShop can be a little difficult to use with alpha channels, the transparency layer required to enable one background, or overlay, to be placed over another.

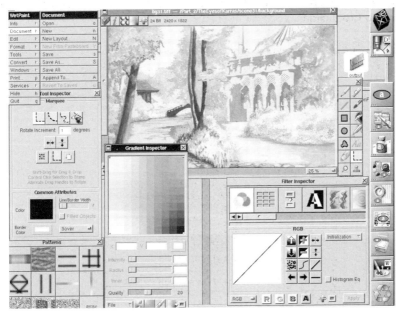

Fig. 4.11 Wetpaint with NextStep operating system.

Fig. 4.12 First pass of overlay with transparent background.

Fig. 4.13 Second pass with black paper behind.

Fig. 4.14 The completed overlay with transparent background.

Animo has its own unique way of creating overlays in the *ScanBackground* application, which works very well. The artwork is secured well and scanned in twice, the first time with any coloured piece of backing cartridge paper and the second time with a contrasting colour. The software sees the conflicting coloured area and converts it to transparency. This is an easy procedure and well explained in the Animo user guide.

Having scanned background artwork into the system you may find the colour or brightness of the image needs attention. This is done with a **colour corrector**. Most often this is solved by simply increasing the saturation within HSV by about 20 per cent. Be careful about altering

Fig. 4.15 Animo's *ColourCorrector*.

these values, as they cannot be reversed. If you make the wrong choice of values in *Colour-Corrector* it would be necessary to delete the work and scan the background in again.

Another source of background material is live-action footage. Provided you have the video player, PVR and capture card it should be easy to introduce single frames of live action into the background in the final composition.

With the correct type of editing equipment and a simple printer it is possible to print out single photographs from live-action material for rotoscoping purposes. Normally, every second or third image is enough for you to copy from for creating realistic movement of people or animals etc. Also, photocopied images of this sort can be very useful in mocking up storyboards when live action needs to be referred to.

Fig. 4.16 Archer's *Background Maker*.

chapter 5

Xsheets, *Director* and composition

The final stage of any animation production is to put the artwork under the camera for shooting. Of course, these computer systems do not use a real camera, but they do use a simulated version. The computer interface screen in this module is a little more complex than the other modules depending to a greater or lesser extent on the software system you have chosen to purchase. The main scene or composition window is called *Drawing Window*, *Current Window*, *Camera Stand* or *Timeline Window*, according to which system you are using. This window allows you to see the assembled scene, including all the elements, background, characters, overlays, and special effects.

Fig. 5.1 Animo's *Director.*

In traditional animation the artwork would normally consist of a background and character drawings inked and painted on cel acetate and placed under a rostrum camera for shooting. Each cel would then be shot in one or more frames according to a list of instructions written on a **dope sheet**. With animation computer systems the **dope sheet** is referred to as the **XSheet** or exposure sheet.

Fig. 5.2 Toonz's *XSheet.*

XSheet

Any instruction inserted in the XSheet directly orders the system to perform the tasks automatically. The start and finish of animation movements is directed in the XSheet with drawings chosen by their number coding as you would in the normal way. Repeat cycles, reverse timings, blanks, holds and inbetweens are used to direct the movements as required. The repeating of a cycle is usually done by highlighting a chosen number of frames along the XSheet column and the use of *Copy and Paste* from the *Edit* menu.

- For Windows and Macintosh computers use the shortcut *Ctrl + C* for copy and *Ctrl + V* for paste.
- To alter the timing from singles to doubles or trebles etc., press *Ctrl + 2*, or *Ctrl + 3* etc.
- To highlight a column of frames, press *Alt* and click on the first frame in the column. All the frames below that one will be highlighted.
- To add a blank to a column press *B* and click the appropriate frame.
- To add a hold press *H* and click on the chosen frame.

Of course, any amount of information can be deleted, simply by highlighting the offending frames and selecting *Cut* in the *Edit* menu or pressing the backspace key on your keyboard.

Fig. 5.3 Axa's *XSheet*.

The XSheet controls *when* things happen in the scene just like any doping information. The length of the scene might very well be determined by lip-sync or some other sound reference. Decide how long the scene should be before you start, remembering to add perhaps a second or two at the beginning and at least three seconds extra at the end. It is surprising how often those extra holds are needed, especially when the editor decides to add a mix to the scene.

The different elements to a scene are loaded in and attributed keyframes in the XSheet. The timings of a move are simply controlled by the placement of the keyframes along the timelines on the XSheet.

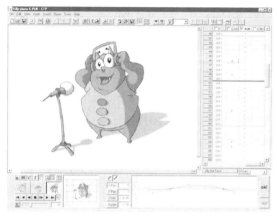

Fig. 5.4 CTP's *XSheet* in *Composition*.

No movement starts and stops at a constant speed and **fairings** or cushioning positions have to be calculated so that a movement starts off gradually (slow-out) and softens when it comes to a halt (slow-in).

When using a real stop motion film camera along a track, either vertical or horizontal, fairings are measured out along a piece of white camera tape, matching the exact length of the total movement. The length of tape is then marked out with the appropriate number of positions according to the total number of frames. The fairings might be calculated so that the camera moves off slowly and comes to rest slowly. The recommended way of calculating these marks is to draw an arc above the length of tape, and measure off equidistant marks representing the total number of frames. If you then draw vertical lines onto the tape, down from each mark on the arc, you will produce a very accurate and quick arrangement of fairings.

Fig. 5.5 Archer's *XSheet*.

Fig. 5.6 Animo's fairings within *Director.*

The many varied options of fairing movements are calculated automatically by the computer and are offered in an array of **timing** or **motion control** choices. These are easily defined in most systems and only experience will help to choose the correct option for a particular move.

Some of these systems even include an **oscillation fairing**. This produces movement in more than one direction out of a keyframe, saving the tedious drawing of a number of them. For example, you could use this to make a ball bounce vertically and gradually come to a halt, or another might help create camera shudder for an 'earthquake' effect.

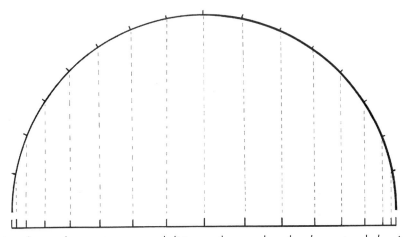

Fig. 5.7 Points drawn along an arc at equal distances then produce the *slow-out* and *slow-in* fairings along the horizontal line underneath.

Fig. 5.8 Animo's *fairings oscillator* in *Director*.

Any number of drawings along the column in XSheet can be retimed. Simply by highlighting them they can be reversed, retimed on singles, doubles, threes etc., and even randomised automatically. The *Randomise* option is particularly useful in saving the operator a great deal of work by not having to make up the random order of frames by hand.

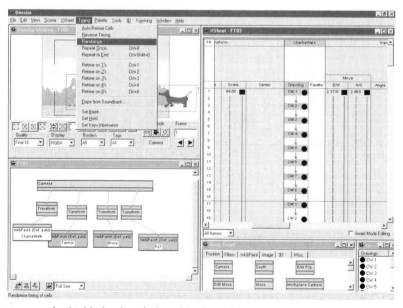

Fig. 5.9 Timings can be highlighted and altered in the XSheet.

Composition Window

Meanwhile, the background is loaded into the main drawing window as a TIFF/TGA file or level according to its source and structure. With the help of a selection of tools from a toolkit the background can then be enlarged, reduced, flipped, or rotated into the required position within the scene. A 'camera' frame grid shows the area of the scene as it will appear in the final result. Any camera movements are then loaded into the XSheet list with a keyframe instructing the start of a move and later keyframe establishing the end of the move.

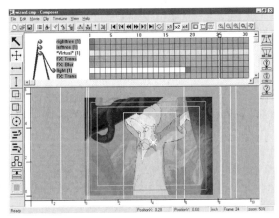

Fig. 5.10 Archer's *Composition* window and timeline.

Any number of animation characters may be loaded into the scene and placed within the composition window. In doing so, each character must be allocated a keyframe in the XSheet column according to the choice of instructions required. For example, if a character is required to move from left of screen at frame 1 of the scene, then having placed it where necessary within the composition window it is allocated the keyframe in the XSheet at frame 1. If the character is to arrive at a position on the right of the screen at frame 150, again a keyframe is simply placed in the XSheet accordingly at frame 150, and the computer calculates the inbetweens automatically. However, this does not mean that all the different animation drawings will be done by the computer; these still have to be drawn in the traditional way, as walk cycles, running cycles etc. Even so, if at the start of the move a character begins small and arrives at the end of the move much larger, this is simply controlled using a scaling tool while the computer interpolates the inbetweens.

Most systems supply a list of tools for the composition window:

- *Select tool.* The main cursor tool used in the composition window to place objects as required.
- *Flip.* Changes the object to a mirrored aspect, E–W or N–S.
- *Pan.* Allows you to drag the window across to view any position you choose.

Fig. 5.11 *Ivon of the Yukon* produced using Toonboom system. (Copyright Ivon of the Yukon, image courtesy of Studio B Productions.)

- *Zoom.* By dragging a boundary box around a region you wish to view the window will enlarge to that area.
- *Scale.* Alters the enlargement or reduction of objects within the window.
- *Rotate.* Alters the rotation of images.

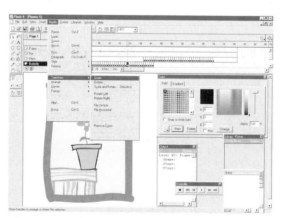

Fig. 5.12 *Flash* interface showing transform controls for *Flip, Scale, Rotate*, etc.

The order of objects within the composition window is easily changed. One level can be simply placed on top of another and rearranged as necessary. If a character walks into the scene behind an overlaid object, and then has to change level by walking in front of that object, this can be achieved simply by loading the overlay in twice, and arranging keyframes with blanks to switch one overlay off, while activating the other.

Fig. 5.13 Animo's *XSheet*.

Scene Graph Window

In Animo, there is another window, called the *Scene Graph*, which is needed to help assemble the final scene. In fact, it sets the structure of an entire scene. A **node** is placed in the *Scene Graph* to load in the background. It is the actual physical selection of a particular **node** in the *Scene Graph* that imports any component or effect of the scene into the *Composition/Drawing* window. If a level of animation drawings is needed next, then again it must be ordered from the computer file system by loading in the appropriate node into the *Scene Graph* first. No importing of artwork can be performed without the use of this procedure of first selecting nodes

Fig. 5.14 Animo's *Scene Graph* window and *Node Panel*.

into the *Scene Graph* window. As each node is loaded into the *Scene Graph* and the character of the scene chosen from the computer files, the image appears in the composition window and keyframes appear in the XSheet for timing instructions. If a plain colour or cove (graded colour blend) background is needed the *Colour Card* node can be imported to produce an expanse of colour. Used in connection with *Colour Chooser*, any colour can be grabbed from a background object to make the expanse of colour behind match.

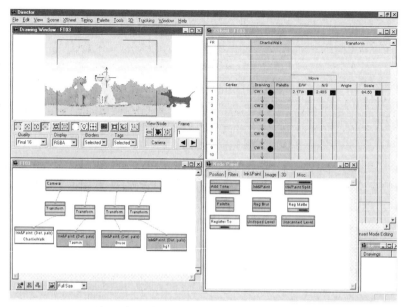

Fig. 5.15 Animo's *Scene Graph* and *Node Panel* as they appear in *Director*.

There is another useful palette node worth mentioning here. With more than one colour palette for a character it is possible to set keyframes for each palette to inbetween, to change smoothly from one set of colours to another. In Toonz, this unusual feature is also available, but in the *Inknpaint* application.

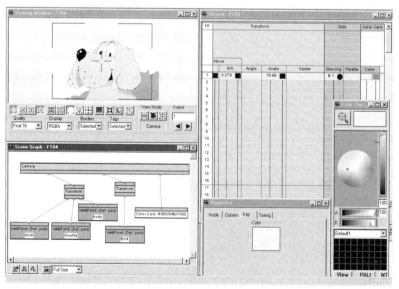

Fig. 5.16 The *Colour Card* has been allocated a colour using the *Magnifying glass* on the *Colour Chooser* to grab the colour from the background.

Camera

The 'camera' frame in all these systems remains in a default position with a crosshair in the centre, and will remain there throughout the scene (there is always the option of switching on and off the camera crosshair, or using other grids, action-safe and title-safe area outlines). However, if you choose to track in, or move out, or pan, the camera keyframes can be simply placed along the timeline to control when such changes should occur. Meanwhile, the camera position is controlled by placing the framing of the camera to align with each keyframe in turn.

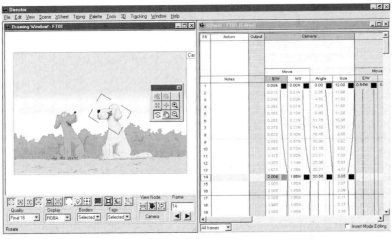

Fig. 5.17 The camera has zoomed in and changed its angle.

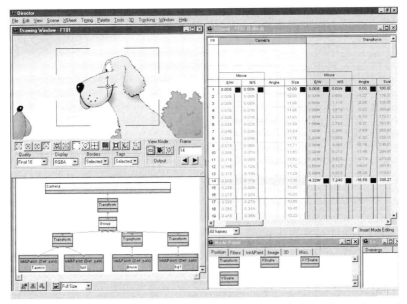

Fig. 5.18 The camera has stayed in place while the background and objects have changed angle and moved in closer.

Fig. 5.19 Blur filter used to add 'depth of field' or multiplane effect.

The computer then automatically works out the different moves for you. The most complex tilts and pans etc. are made easy by these systems. The camera can be altered by applying a rotation or scaling value simply placed at the appropriate keyframe in the XSheet.

Fig. 5.20 Softimage Toonz's *Multiplane* camera.

In a similar fashion the camera can be chosen to remain still while the scene or objects within the scene pan or move as you might wish. This is done, again, by simply according different actions a keyframe along the timeline for each position at the start and finish of the move. The computer works out the in-between frames automatically, with the different motion control options available as well: *slow-in* (*ease-in*), *slow-out* (*ease-out*), *linear*, etc.

In live-action filming the cameraperson might choose to pull focus, altering the depth of field so that the foreground might appear blurred and out of focus while changing the focus to the far ground, or vice versa. In animation the multiplane camera work simulates the same effect.

SoftimageToonz has an excellent Multiplane program, which allows you to change the position of the camera and see the results in real time. The focus values and depth of field are automatically changed while you adjust the image to your choice. Many other systems also include multiplane facilities, but Toonz has been designed specially for the traditional cameraperson to understand and use easily.

Effect Filters

All these systems have a list of effects to be used in this application. Some systems have more than others and some work better than others. On the whole, you get what you pay for.

- **Blur filters** may be used to alter the focus on foreground or background and to help create a multiplane effect, or to blur a character to produce the illusion of **swish**. In the latter case the character must be loaded in twice and the blur filter applied to one of the two character files, so that the full normal drawing of the character leads the movement with a blurred effect

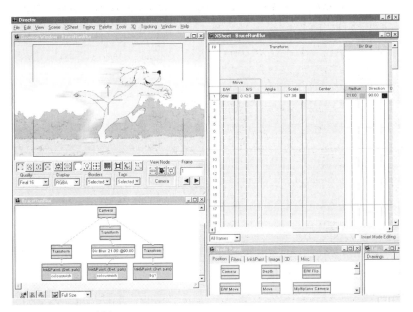

Fig. 5.21 Animo's *Directional blur.*

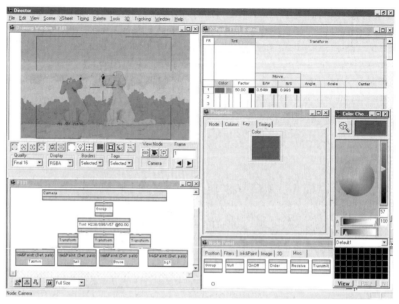

Fig. 5.22 Animo's *Tint* node.

trailing behind. It is also a useful filter applied to a snow cycle, smoke, or an underwater feature to produce a realistic result. It is particularly effective when applied to the background on a close-up shot. It is best to experiment, depending on the system being used, but be careful how you use this computer device. Choose the least value possible according to

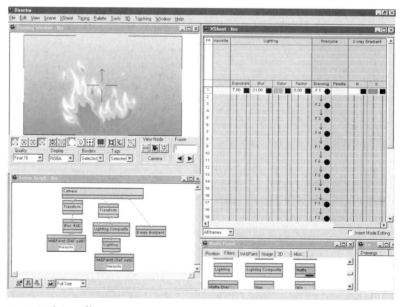

Fig. 5.23 Animo's *Lighting* effect.

needs, as the use of this filter seems to induce a strain on the computer and may develop problems or cause the computer to crash if unnecessarily overused.

- **Colour filters**. These can be used to tint a background or character, giving the object an overall colour bias. This can be very useful during a night-time or underwater sequence. A separate drawing needs to be made and scanned in, and painted accordingly. Associated with an *opacity filter* it can be used to great effect.
- **Lighting** effects can be applied to create **backlighting**, sometimes in conjunction with a *blur filter* to complete the effect of a glow. This is very good when used with a fire cycle, or lighting on a background, perhaps where light streams through a window etc.

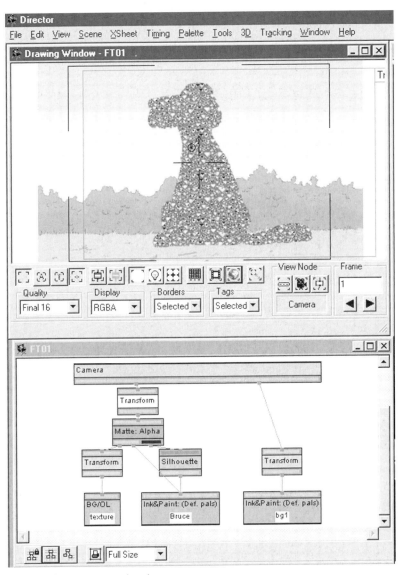

Fig. 5.24 Matte used here to cover the character in a texture.

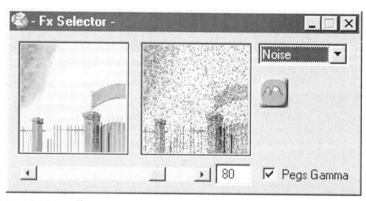

Fig. 5.25 MediaPegs' *Noise* effect.

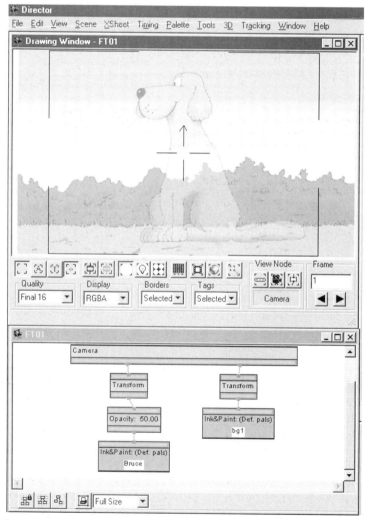

Fig. 5.26 The character is a given a 50 per cent transparency using the *Opacity* node.

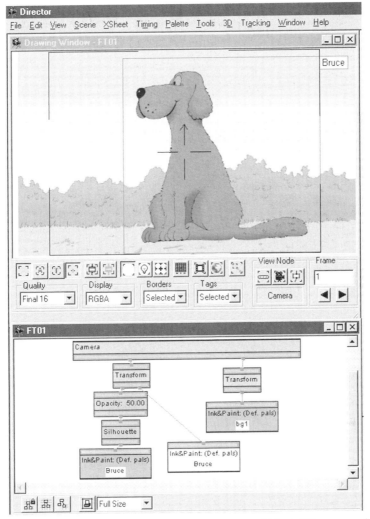

Fig. 5.27 The character is overlaid with a 50 per cent *Opacity* and black *Silhouette* node.

- **Mattes** are used to help create overlays from backgrounds or to cover certain areas of a character with a texture. They can also be used to produce a 'reveal', where a single object might appear in a gradual unveiling sequence. This way the object needs only to be drawn once, while a series of mattes complete the finished result.
- **Noise** sets a random colour variation simulating a granular effect. This might have some use when creating a dust storm over a background.
- **Opacity** alters a background or character to make it transparent or even disappear altogether. The degree of transparency is controlled by a numerical value graduating from 0 to 100 per cent. This effect is useful in helping to create shadows with a degree of transparency. Also, if a character moves out of a heavily shadowed area in the background into a brighter area in the centre of the screen his body can be made to lighten gradually

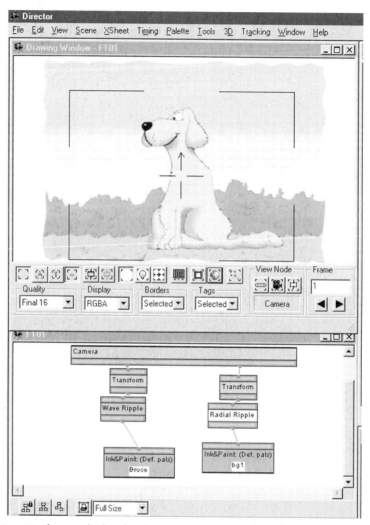

Fig. 5.28 A *Wave Ripple* is applied to the character and a *Radial Ripple* is applied to the background.

accordingly. This is done with the addition of a separate black silhouette drawing laid over the character, given, say, 75 per cent opacity to start with and then reduced to 0 per cent when the character arrives in the middle of the screen. The result can look very effective and is easy to perform. Simply place a keyframe of the effect and the shadow drawing at 75 per cent on the XSheet, at the start of the scene, and place the final keyframe of 0 per cent further down the XSheet where the character arrives in the bright centre of the scene, and the computer will create the inbetweens automatically.

- **Ripple filters** usually include a *wave* or *radial ripple*, and some systems include more options as well. The results created are usually for underwater scenes or water surface effects. The *radial ripple* makes the effect of a wave spreading out from the middle of a circle on the surface of water as if caused by a pebble being dropped into the centre. A *wave ripple*

Fig. 5.29 MediaPegs' *Twirl* effect.

Fig. 5.30 MediaPegs' *Flash* effect.

Fig. 5.31 MediaPegs' *Reverse* effect.

distorts the image as if it were underwater. This effect used to be created with a *ripple glass* under the camera on a rostrum, but was always difficult to achieve, especially when the scene lasted longer than the length of glass available! A *grid ripple* distorts the image using a square grid as its controlling parameters. All these filters have a large capacity for distortion and need practice to appreciate fully their potential. As a general guide, use the smaller values in the sets of controls for realistic effects.

● **Twirl** deforms the image by whirling its pixels around its centre. This effect could be used to create a vortex as in a tornado, or a dream sequence.

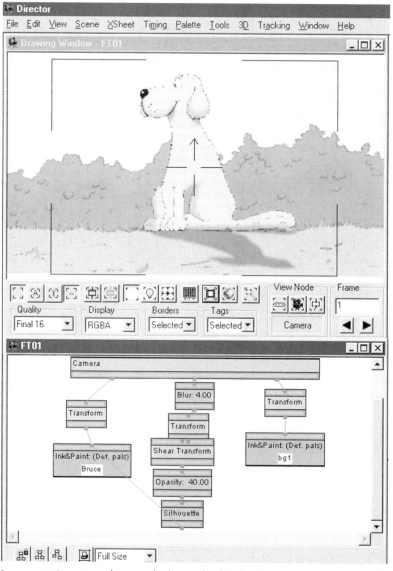

Fig. 5.32 40 per cent *Opacity* node is applied to make the shadow transparent and a *Blur* node is added to soften the edges.

- One effect which is totally unique to MediaPegs is *Flash* – not often required but very useful when creating a flash of lightning on the background. The image is changed to the extreme contrast of black and white; perfect for simulating a realistic thunderstorm when it is doped in on the XSheet for the odd frame or two. If this is followed after a few frames of the normal background with a streak of lightning, again just for the odd frame, the result can look very convincing.
- MediaPegs' *Reverse* effect produces a negative of the image. This could be a useful tool when applied as an effect from an alien laser-gun or electricity spark, for example.

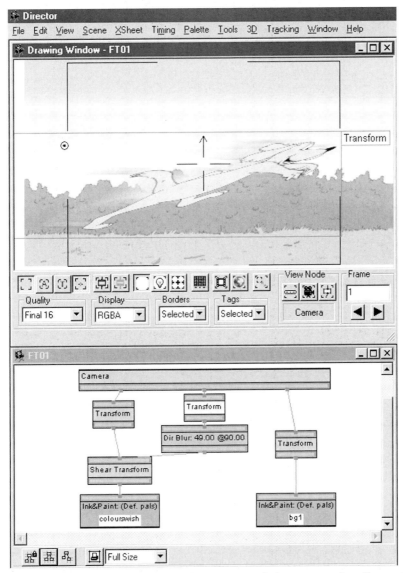

Fig. 5.33 A *Shear Transform* is used together with a *Directional Blur* to create this effect in Animo.

Shadows

When preparing the drawings for a sequence of animation do not concern yourself with the extra work of drawing shadows. These can be produced in the composition stage of production using the ordinary animation drawings themselves. This is done by loading the drawing file into the composition window twice. Take one of the files and, by using a range of effect filters, make the whole image black, give it a percentage opacity, distort the shape and position it to fit with the moving character. Using this technique, the results work very well, because as the character moves the shadows follow in a very realistic fashion.

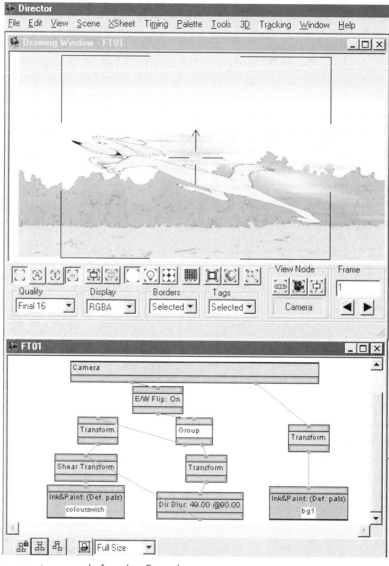

Fig. 5.34 The same image as before, but flipped.

Distortion

Some systems provide a facility for distorting images using either particular filters, tools or *shear nodes*. This facility is particularly necessary for flattening shadows. It can also be used to squash or stretch a character, saving extra drawing work. Sometimes the response can be more dramatic and realistic than a hand-drawn attempt to simulate the same effect. For example, if a character needs to run faster, using a distortion effect to stretch the character forward can improve the overall result, especially when applying a blur filter as well.

Flipping or flopping a character or background is usually very simple to do, either N–S or E–W. This is particularly useful when a character runs in screen from left to right and then runs through on the return journey from right to left. Obviously, only one set of drawings is required and then flopped for the return journey.

MediaPegs use a *Mirror* tool in their *Fx Selector* for reversing the image.

Fig. 5.35 MediaPegs uses *Mirror* to flip the image.

Paths and Splines

Sometimes a character needs to run or travel along a curved line, or a camera movement requires a smooth, curved trajectory to move from one position to another. This is performed by drawing a path or **spline** for the object to follow. The method of creating these paths is determined by the different computer systems available. Once the line is drawn a keyframe is created in the XSheet for the start of the path and then another keyframe is placed at the end of the move. The timing depends on the position of the second keyframe along the timeline of the XSheet, and the direction of the path is determined by the shape of the initial drawn line, but then further manipulated by adjusting the **tangents** along the path. The paths are purely for creating the direction of movement and do not appear in the final image on screen.

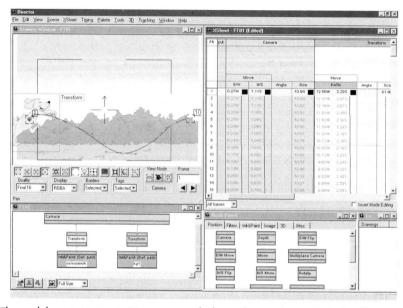

Fig. 5.36 The *path* here in Animo's *Director* controls the pathway along which the character moves.

However, when drawing vector curves as structures of a character the computer system uses a similar method to draw the splines and paths, again with the useful manipulation of the lines by tangent adjustment. In vector animation it is the adjustment of the tangents that cause the structure of the character to change and animate.

Depending on the computer system being used there are usually several tools available to help draw the vectors and other aids, such as *Keyframe markers, Knots, Segments* and *Tangents* to animate the structure.

Fig. 5.37 Vector lines with adjustable *tangents*.

Lip-sync

Many animators shy away from using lip-sync where budgets are limited, but it could be argued that a character standing still, making the occasional head and arm movement with lip-sync, is far less work than having to create some other movement where lip-sync is not used.

Traditionally, it has always been the responsibility of the film editor to break down the soundtrack into individual parts of speech, called phonemes, for the benefit of the animator, only because he or she was the person used to handling film material and had the means and skill to do the job. The phonemes were then written down on bar sheets for the animators to follow.

The synchronisation of the beginning of a word and the end is more important than the accuracy of the middle. This is useful to bear in mind if you lack the skill and practice of breaking down a soundtrack.

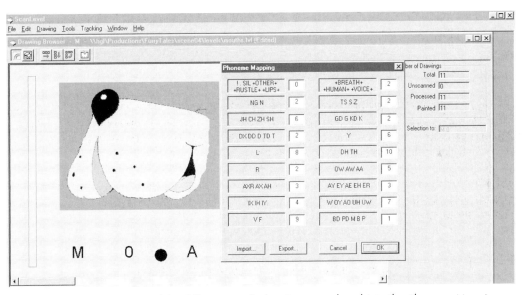

Fig. 5.38 In Animo's *ScanLevel* the different mouth drawings are placed into the *Phoneme Mapping*.

Now with new programs available for this purpose the job is easier, usually incorporated within the computer system and can be connected directly to the animation. In a vector system the different mouth drawings are automatically associated with the different phonemes, so that once the character has been identified with the soundtrack the lip-sync automatically follows.

In Animo the *SoundTrackEditor* provides an excellent method for defining the lip-sync. When the different mouth movements are first scanned into *ScanLevel* they are then allocated to a choice

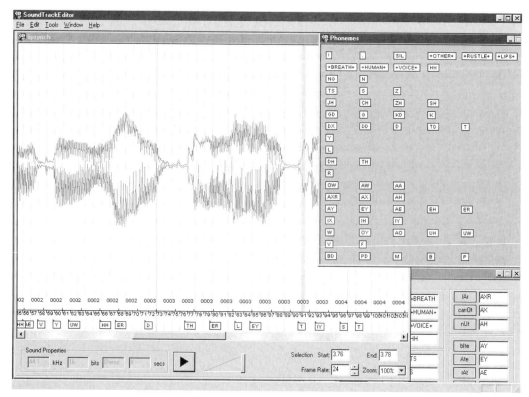

Fig. 5.39 The sound is broken down by allocating different phonemes along the timeline in Animo's *SoundTrackEditor.*

of phonemes. In *SoundTrackEditor* you can then place each phoneme along a timeline to break down the soundtrack. In the final stage of putting the scene together in *Director* the soundtrack is loaded into the XSheet and the mouth drawings also included in a separate column, where they are then automatically aligned to synchronise with the sound.

There are ten basic drawings to cover the range of mouth movements for lip-syncing. Keep to a regular code for each mouth drawing and learn them so that you can number the frames along the XSheet quickly and efficiently without having to refer to the drawings (see page 34, Figure 1.18).

Progress Sheets

It is very important for members of the production team to know which files are complete and when files are ready for the final composition. It is therefore advisable to keep some form of record of progress to avoid a total muddle.

As levels of drawings are scanned into the computer a list of these files should be made immediately. This will inform the inkers and painters which files need their attention and

which are complete, and also let the director know when files are ready for his or her use.

Scene	Character/background	Scanned	Painted	Colour corrected	Composed	Rendered

chapter 6

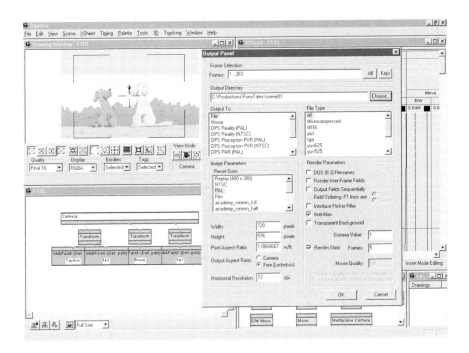

rendering and output

Replayer

When the scene has been completed in *Compositor* it needs checking in the *Replayer*. All these systems have some form of replay/line-testing facility which should be used whenever possible. It is particularly necessary to preview the scene at this stage before the scene is rendered out to disk to avoid wasting time if the composition is faulty in any way. It is very easy to think that everything is correct and as it should be until you replay the scene and discover some little fault you had not thought of. This can happen time and time again, so always check with the *Replayer*. If you have the choice of testing the scene in line *Test mode* or full *Final mode* it is better to see the final image as much as possible, checking to see that not only your setting up is correct, but also that the computer is behaving itself.

Fig. 6.1 Archer's *Movie Player.*

Rendering

Up until this stage the scenes of animation production still remain within the computer and need processing to an outside source for film or video making.

For video this is done by rendering the digital information into a language understood by a PVR (Perception Video Recorder), PAR (Personal Animation Recorder) card, Hollywood or Reality, all supplied by DPS (see Chapter 7).

For film the information is usually rendered onto the computer's hard disk where it is then transferred onto some form of tape or CD-ROM and taken to a laboratory for processing onto film. This process is extremely expensive and you should investigate this before you start any film productions.

Make sure for all outputting that you have *all* the correct equipment available and your system is configured correctly for this final stage of processing.

The process of rendering can take up a great deal of time, depending on the nature of the files within the composited scene, duration of the scene and amount of information the computer has to process. This is best performed overnight, during downtime, when the equipment is not needed for production work, although most systems do allow for multitasking. If you do choose to render during the working day you will find most applications very slow and tiresome to work with. The computer will always apply itself to rendering as its most important function while you are desperately trying to perform some other task.

Fig. 6.2 Animo's *Output Panel*.

Batch Output

All computer systems render the animation scene as a sequence of single frames saved to the hard disk of the computer in bitmap formats as TIFF, TGA, BMP or PICT files. This is performed via a batch system, which composes the final images and saves them to the disk. From there they need to be output onto a digital disk recorder, and transferred to video, CD or Zip drive, etc. The system can be configured to output automatically according to what equipment is being connected to the computer, and whether the computer software supports that type of peripheral. It is important to try and understand this process a little and find out as much information as possible about the final stage of your output. It is vital to ensure that your end product, film or video, can be extracted from the computer onto the format required.

Fig. 6.3 Animo's *Batch Monitor.*

chapter 7

File	Edit	View	Image	Drawing	To
New Model...				Ctrl+N	
New Traced Level...					
Open...				Ctrl+O	
Open Selection...					
Close					
Save				Ctrl+S	

hardware and general information

Most of the advice and content of this book is based on the Animo computer system. This, together with Softimage Toonz, is one of the most sophisticated of all the systems available in today's market, with a wide range of abilities. Some of the other systems are more modest and simpler, and their prices reflect this.

Hardware

The recommended hardware for Windows NT is a Pentium III PC including:

500 MHz Pentium III Processor
256 MB RAM
512 KB Cache
4 GB System Disk
SCSI CD-ROM
3.5" Disk, mouse, keyboard
17"/21" Colour monitor
SCSI Adaptor
4 MB Video card
10/100 MB Ethernet

The most commonly used scanner for black and white animation drawings is the Ricoh IS420 A3 monochrome scanner (including ADF and SCSI2 interface). For colour backgrounds the recommended choices are the Epson GT12000 A3 colour scanner or the Hewlett Packard 6100C A4 colour scanner.

To output to 656 digital video the recommended options are:

DPS Hollywood HVR3800 digital video card (uncompressed serial digital)
4 × 4 GB wide SCSI disks for above – approximately 5 minutes real-time video playback
DPS AC3800 PAL real-time alpha channel option
DPS Perception Video Recorder
DPS Reality RDR-5000
Video server PC – Pentium 166 MHz with 32 MB RAM + 2 MB video card + NT
Sony 14"/17" broadcast monitor, YUV or serial digital

DPS can be contacted at:

Digital Processing Systems Ltd
Unit 9, Romans Business Park
East Street
Farnham
Surrey GU9 7SX
Tel: +44 (0) 1252 718300
Fax: +44 (0) 1252 718400
Email: sales.europe@dps.com

If your computer does not already include a built-in modem then a recommended choice would be the Multitech II MT1932ZDX multi-modem.

Software
Back-Up

It is essential to include a back-up system with your equipment for day-to-day storage of data and for permanent storage of completed projects. There is a limit to what any hard disk can store and it is inevitable that you will need to offload some of your work onto tape for future storage. You then might choose a SCSI DDS-2 DAT tape drive: either a Hewlett Packard 1533A or a Sony SDT-5000.

Defragmentation

It is highly recommended that you include a defragmentation package on your shopping list of software. As production files are stored onto the hard disk, temporary files come and go leaving empty spaces in between. A folder of files can then be left with bits and pieces as random fragments on the disk. A defragmentation software program such as Diskeeper is relatively cheap to buy, simple to use and will help keep your files stored neatly and tidily on your hard disk. This will considerably improve your computer's performance. Contact:

Executive Software
701 North Brand Boulevard, Sixth floor
Glendale
California 91203
USA
Tel: 001 818 547 2050
Fax: 001 818 545 9241
http://www.executive.com

Fig. 7.1 Diskeeper's defragmentation software tidies up the hard disk.

General Information

Usually the animation software is installed on the hard disk marked *C*, but, these days, on some larger machines the hard disk is partitioned into two or three parts, often *C*, *D*, and *E*. This should not interfere or cause any problems with the software if it is configured correctly. It is usually found under *C:/Programs/* . . .

Create application shortcuts for your desktop and store them apart, on the right side of your screen opposite the left-hand screen list of usual icons. By keeping the icons separated in this way they can be easily recognised. In the same way, you can use the top of the screen to make shortcuts for your productions. To open any application or folder, just double-click on the icon. To open a file choose *File/Open* from the main menu. To close the file or application you are working on click once on the *X* at the top right-hand corner of the window. The little box to the left containing a 'square' enlarges the window to full screen and then offers the ability to reduce it once again.

Fig. 7.2 Main menu.

One of the most important menu items available is the *Undo* option under the *Edit* menu. This is very useful when you make the inevitable mistake of deleting something. The computer should restore the missing information with *Undo*. Some software packages will allow you to retrieve anything from the last 20 functions you have made. Also, you can use the keyboard shortcut *Ctrl + Z*.

Many applications have a toolkit, which can be displayed by pressing the right mouse button while placing the cursor over the appropriate window. Then, just place the cursor over the toolkit and select the tool by clicking on it.

Fig. 7.3 *Hide, Fullscreen,* and *Exit* boxes.

Always remember to save everything. Get into the habit of regularly saving every few minutes, if your system does not auto-save. The keyboard shortcut is *Ctrl + S,* or you can find *Save* under the main *File* menu. *Save As* creates a new version of your file under your choice of a new name.

To quit any application choose the *File* menu and press *Exit,* or use the keyboard shortcut *Ctrl + Q.*

Fig. 7.4 *Edit* menu.

Preferences

Throughout most computer systems and within each application there is usually a preference menu (often found in a tools menu). Apart from the default settings you are offered a variety of different choices of values and settings to suit your own personal needs. Take advantage of this facility as much as possible. It will make your interface more comfortable to work with.

Some applications require numerous windows on the screen at the same time. These can be manipulated into position, enlarged or reduced according to needs, but having established a preferred set-up it will help your workflow if you keep to it and save the arrangement you have chosen.

Command Prompt

Some file extensions do not work very well with a DOS operating platform like Windows, because the system only recognises three letters and not four. So, for instance, a TIFF file must be reduced to TIF to enable it to be used in some applications. This can easily be performed using the command or MS-DOS prompt if you are using Windows 95, 98, 2000 or NT.

Immediately after the *C:* type *cd*, leave a space and then drag in the folder containing the file to be renamed. Do not drag in the file itself only, but the whole folder. Press return.

Then type *dir*, leave a space and type */w* and press return. This then reveals the whole contents of the folder. Now type *rename* and leave a space and type the file name, i.e. *Bloggs.TIFF* leave a space and type *Bloggs.TIF.* That file extension will then be renamed accordingly.

Printing

The cheaper ink jet printers such as an Epson Stylus Color 660 are quite adequate for most uses but for top quality printing at a professional level you should look to a specialist dealer for advice. Usually the cheaper ink jets will print the information available from the screen. However, on other occasions, it may be necessary to use a capture facility to screen grab the interface graphics, save as a TIFF and arrange to print from some other application. A capture facility is available using PaintShopPro software, and Version 4 has been given away free with some magazines.

Software Suppliers

Animo

The software provides users with a comprehensive toolkit to create animated productions in digital format starting from scanning paper drawings through to outputting onto film or video tape. Many of the digital production techniques emulate traditional methods. Available from:

Cambridge Animation Systems
Titan House
Castle Park
Cambridge CB3 0AY
UK
Tel: +44 (0) 1223 488200
Fax: +44 (0) 1223 488201
http://www.cam-ani.co.uk

Fig. 7.5 Animo software.

Archer

It is designed as a modular software and can be configured according to differing work environments. A bitmap system offering *Scanning, BGMaker, Analyzer, Painter, XSheet,* and *Composer* modules. Distributed by:

BIT (UK) Ltd
Nether Street
Alton
Hampshire GU34 1EA
Tel: +44 (0) 1420 83811
Fax: +44 (0) 1420 80657

Fig. 7.6 Archer software.

Axa Animation Software

Axa Team 2D Pro animation software package has been designed for use on all Windows platforms. Written by:

> Research Engineers
> 22700 Savi Ranch Pkwy
> Yorba Linda
> California 92887
> USA
> Tel: 001 714 974 2500
> Fax: 001 714 974 4771
> http://www.reiworld.com/dma/axa.asp

Distributed in the UK by:

> AXA-AVA Animation Software
> 89 Groundwell Road
> Swindon
> Wilts. SN1 2NA
> Tel and Fax: 01793 485541
> Email: bud@cix.co.uk axa@gobiz.co.uk

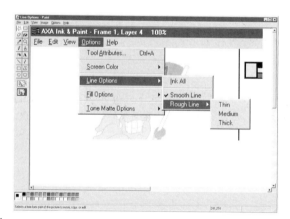

Fig. 7.7 Axa software.

CelAction

This system so far has been designed specifically for traditional cut-out animation, relying on PhotoShop to create the artwork. It is one of the cheaper systems available and very easy to use. While lacking a little of the sophistication and the wide range of facilities of some other systems, the software is being developed further.

Tel: + 44 (0)207 226 3649

Chromacolour International Ltd

Equipment suppliers for animation, including paints, cel, paper, books and computer line-tester:

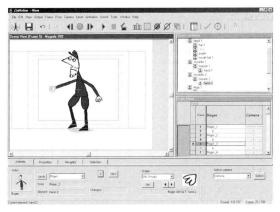

Fig. 7.8 CelAction software.

Pilton Estate
Pitlake
Croydon
Surrey CR0 3RA
Tel: +44 (0)20 8688 1991
Fax: +44 (0)20 8688 1441
Email: sales@chromacolour.co.uk

Crater Software

CTP (Cartoon Television Program) is a PC-compatible program designed to make broadcast-quality television cartoons using Windows 98 or NT. It claims to be one of the simpler systems and one of the cheapest. Head office:

1550 Metcalfe
Suite 1500
Montreal
Quebec
Canada H3A 1X6
Tel: 514 284 7771
Fax: 514 284 4847

Distributed in UK by:

Polar Graphics
Talbot House
204–226 Imperial Drive
Rayners Lane
Harrow
Middlesex HA2 7HH
Tel: +44 (0) 20 8868 2479
Fax: +44 (0) 20 8866 8207

Fig. 7.9 CTP software.

CreaToon

A PC software system for creating 2D animation in cut-out mode. Head office:

Androme NV
Wetenschapspark 4
B–3590 Diepenbeek
Belgium
Tel: +32 1130 1330
Fax: +32 1130 1331
http://www.creatoon.com/contacts.asp

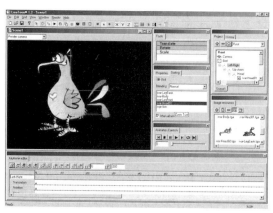

Fig. 7.10 CreaToon software.

Flash

A vector-based software system for creating animated displays, text, audio and interactivity on the website. Designed specifically for Internet animation with a generous range of facilities, but its purpose is too limited for general film and video production.

Macromedia Software
Tel: 0870 600 1042
http://www.macromedia.com

Fig. 7.11 Flash software.

Linker Systems

Animation Stand is an easy-to-use computer-assisted 2D character animation compositing system. It provides versions for all major platforms: Mac, SGI and Windows 95, 98, 2000 and NT.

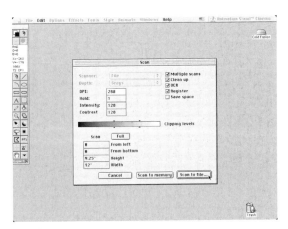

Fig. 7.12 Animation Stand software.

13612 Onkayha Circle
Irvine
California 92620
USA
Tel: 001 877 489 3525
Fax: 001 949 552 6985

MediaPegs

A 2D animation production system running on Silicon Graphics stations and Windows NT platforms. The system digitises the entire post-paper animation production process from scanning to recording.

80/84 rue de Paris
93100 Montreuil
France
Tel: +33 1 48 18 3070
Fax: +33 1 48 18 3071

2861 Seattle Drive
Los Angeles
California 90046
USA
Tel: +1 323 850 5802
Fax: +1 323 850 5804

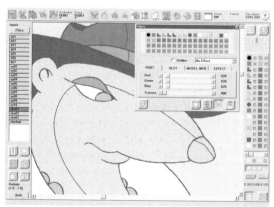

Fig. 7.13 MediaPegs software.

Retas!Pro

A Japanese digital animation system incorporating *Pencil Test, Scan & Trace, Ink & Paint, Compositing & Special effects*. Available for PCs or Macs.

TriMedia Inc
148 North Le Doux Road
Beverley Hills
California 90211
USA

Fig. 7.14 Retas!Pro software.

Softimage Toonz

Toonz is distributed all over the world by Avid/Softimage and is produced by Digital Video Srl. in Rome. Besides Toonz the company also develops a complete set of tools for 2D animation. *Linetest* (www.linetest.com) provides a simple and powerful tool for doing the *Pencil Test*. The work produced while doing a line test (including the exposure sheet compilation, and all the camera and pegbar movements) will be immediately reusable into Toonz for an exposure sheet-driven production. The *Toonz DS* plug-in recreates a real 2D environment inside the post-production one; the plug-in is completely integrated with Toonz and DS. The *Export 3D scene* exports a 3D scene from Softimage 3D into Toonz, thus allowing the 2D characters to follow the movements of the 3D ones.

Digital Video Srl.
The Toonz R&D Company
147 via Jenner
00151 Rome
Italy
Tel: +39 06 5327 1870
Fax: +39 06 5820 4283
http://www.divideo.it/toonz

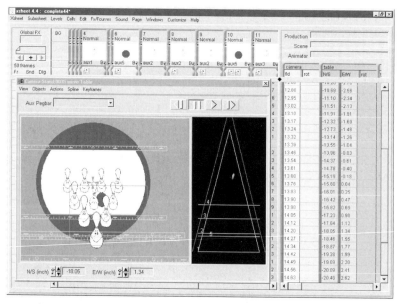

Fig. 7.15 Toonz software.

Toonboom

The only 2D cel animation software company providing 100 per cent vector-based, resolution independent systems.

Fig. 7.16 Toonboom software.

Toonboom Technologies
7 Ave. Laurier Est
Montreal
Quebec
Canada H2T 1E4
Tel: 00 514 278 8666
Fax: 00 514 278 2666
http://www.toonboom.com

Many of these companies are based abroad and create new distribution arrangements all the time. Therefore this list is by no means definitive.

Fig. 7.17 Toonboom was used to create *D'Myna Leagues*. (Image courtesy of Studio B Productions.)

Free Download Files
Adobe Acrobat Reader

http://www.adobe.com/prodindex/acrobat/readstep.html

CreaToon

Free demo and tutorial manual:
http://www.creatoon.com

Downloading

Offers many free packages on the Internet for artists, animators, video editors and graphic designers. This is a very useful website:
http://download.cnet.com

Isis Drivers

Some software drivers for some scanners are downloadable free, but most have to be paid for.
http://www.scannerdriver.com

Linker Systems Animation Stand

Tutorial manual:
http://www.linker.com

QuickTime

http://www.apple.com/quicktime

Retas!Pro

Tutorial manual:
http://www.retas.com/download/manual51.html

Demo software:
http://www.retas.com/download/demo.html

Wetpaint

For anyone still using NextStep which is no longer a shipping operating system, free software products like Wetpaint and others can be downloaded from:
http://www.peak.org/next/apps/LighthouseDesign/

chapter 8

case studies

The following sections discuss some of the computer systems in use and describe their usefulness and the teething problems people have had to face in this marvellous new revolution of technology.

Let us thank those who never gave up!

Pencil & Pepper Animation Production & Technology Consultancy: Production techniques using Animo 3

In late 1999 Pencil & Pepper Animation was commissioned to make four television commercials for Hughes Electrical, a chain of regional electrical goods stores. The commercials were to be aired during the Christmas season and the New Year sales. The job entailed designing a family of characters; storyboarding scripts supplied by the ad agency, John Mountford Studios; analysing the dialogue soundtracks; animating the action on paper and then finishing the commercials on a PC using Animo 3 software.

Fig. 8.1 Hughes Electrical commercial.

Colour Styling

After the initial meeting to discuss the project and the budget, rough character design sketches were drawn on paper. Once these designs were approved each character was drawn cleanly and scanned into the PC using Animo *ScanLevel*. A colour reference model (CRM) was created for each character. Colours were chosen, placed in a palette and painted onto the reference drawing. Then all the painted reference drawings were composited together in Animo *Director*, where further decisions about colours could be made in the context of the whole family of characters. A JPEG of the painted group was rendered from *Director* and sent, via email, to the

Fig. 8.2 The painted group of characters.

agency for colour styling approval. When changes were suggested, new colours could be dropped into the palette, automatically repainting the character, and the results emailed immediately. The final decision on the colours was quickly achieved.

Animatics

The agency produced four scripts and the crew at Pencil & Pepper turned them into storyboard ideas. Once the storyboards were approved on paper, they were scanned into the PC and each storyboard panel was cropped in PhotoShop and saved as a JPEG. The individual storyboard panels were then imported into Animo *Director*. So too were the pre-recorded WAV soundtracks of the dialogue, spoken by the voice actors. The storyboard panels were ordered and timed, with reference to the soundtrack. The camera could zoom and pan smoothly over the panels. Dissolves, fade-up of superimposed text, and cut-out style animation of significant character action all contributed to making detailed animatics that served as a clear indication of how the finished ads would look. These animatics were rendered as AVI files with sound, cut onto a CD-ROM and couriered to the ad agency and client company for approval.

The *Director* files created at this early planning stage contain useful information about the movement of camera and artwork, and shot length. They are saved to disk as SCENE files so they may be used later at the compositing stage, avoiding the need to re-create this information.

Lip-sync

The WAV dialogue soundtracks were opened into Animo *SoundTrackEditor* application. A line of dialogue was selected from the sound wave display, and the corresponding text was copied

from the script's DOC file and pasted into the text field of the *SoundTrackEditor*. Within seconds the line of dialogue was analysed into its phonetic components. In a short time all the dialogue had been broken down into phonemes and accurately distributed across the 500 frames that comprise the length of the ad. This lip-sync breakdown was printed out in a bar sheet form that could be attached to the lip-sync column of a dope sheet, ready for the animator.

Animation

The animation was created in the traditional manner on paper. Rough drawings in blue pencil were cleaned up with lead pencil. Each drawing was marked down in its appropriate level in the dope sheet. The lip-sync was drawn and doped by referencing the phonetic breakdown provided by the software. Because the design of the ad required a heavy black thick and thin outline the final drawings for scanning were drawn with a felt tipped pen. The shape of the outlines were edged in black, ready to be filled in by the computer. This was much quicker than blacking them in on the paper. The drawings were grouped according to the doped levels and wrapped in a coversheet ready to be scanned. For these ads, the backgrounds were created in the same way as the animation levels.

Scanning

Once some of the animation had been completed to final clean-up stage the scanning could begin. With Animo *ScanLevel* each drawing was scanned into the computer using a Bell & Howell automatic sheet-feed scanner, and saved to hard disk with a name corresponding to the one it had been given in the dope sheet. The file structure of the NT operating system was used to group the hundreds of drawings systematically so that nothing got lost, and each drawing was given a unique name and location in the file system.

Image Processing

All the scanned drawings needed to be passed through Animo *Image Processor*. This application analysed the drawings into regions, ready to be painted with colour. It can search for and fix gaps where colour may bleed out into unwanted regions, though it does not alter the drawn line itself, only the underlying regionalisation. Brightness and contrast may be changed in order to blacken the lines and whiten the paper area of the drawing. Once appropriate values for regionalisation, brightness and contrast were chosen they could be applied to many or all the drawings at once as a batch process that was taking place while the operator got on with other tasks.

Some shots required levels of tone matte drawings to define areas of shadow or highlight colour on the character. These drawings are blobby shapes that need only be painted black. The *Image Processor* fills these shapes with black automatically while generating the region information.

Paint and Ink

The drawings were now ready to be coloured. Each level was opened into Animo *InkPaint* and the appropriate colour reference model, made earlier during the colour styling stage, was added to it. The drawings in the level were painted with the model colours by simply choosing a colour and clicking on the regions in the drawing where that colour should be located. One technique is to fill all the large regions corresponding to one colour on a drawing, and then advance to the next drawing and do the same, until that colour has been added to the whole level. Then to choose another colour and fill all the large regions throughout the level that correspond to it. Soon all of the drawings in a level have been largely painted, and then, by using a bounding box fill tool, the smaller details can be easily finished off. For these ads the last thing to be painted was the heavy black outline, which was quickly filled with a bounding box across the whole drawing.

Some parts of the characters needed to be inked with a colour other than the default black. The father's shirt, for instance, required thick pink stripes. These lines were painted with a pink ink colour available from the palette. This pink ink colour had also been given the property of thickening the drawn line so that when the line was clicked with the inking tool it changed from black to pink and thickened by a determined amount.

Finally, all the painted drawings were cleaned with the 'hoover' tool. This removes any unwanted ink areas that are due to dirt on the paper or on the scanner glass.

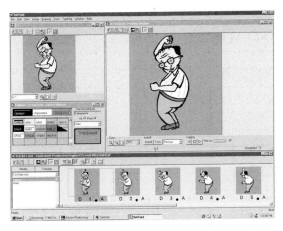

Fig. 8.3 Animo's *InkPaint*.

Special Artwork

The pack shots required special artwork to be made using logos and product photos recreating the look of the Hughes' Christmas brochure. Various components were supplied, as PhotoShop and Illustrator files, by the client company's art department. These components were then combined, in PhotoShop, with drawn and painted elements and the resulting artwork was saved

as high resolution TIF files, with alpha channel information providing the transparency around the image.

Compositing

The many levels and the special artwork were now ready for compositing. Animo uses a scene graph as a graphical representation of the compositing structure of the scene. The scene graph is a hierarchy of linked nodes, with input nodes (levels, backgrounds and other artwork) at the bottom of the hierarchy. These inputs are then fed through other nodes that reposition or filter them in various ways. Finally these image elements are passed into a camera, in a specified order, that displays the current state of the composited image on the screen.

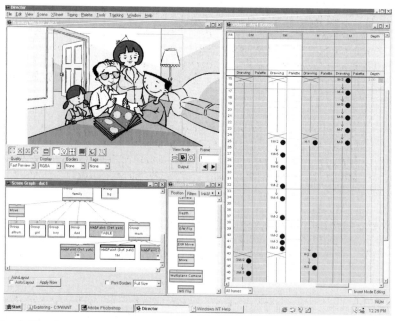

Fig. 8.4 Animo's *Director*.

The SCENE files created at the animatic stage were used as the starting point for compositing the final shots. They were opened into *Director* and the painted levels were substituted for the storyboard panels. The levels were ordered, and the drawings were arranged on the frames, according to the information in the dope sheets. Where several levels comprised a character they were grouped together in the scene graph for clarity. The named group node could be closed from view when it was not being worked on.

Most often the character's position and size on the screen was correct because the scan process preserves the peg position information. But in some cases the peg position had to be overruled for a particular effect or to improve the composition. In these cases new translate, scale and

rotate information was created and applied, as a transform node, to the level. Some shots were created by combining movement that was drawn and inbetweened on paper with movement created by setting key position and size information for artwork and letting Animo generate the inbetweens.

Several shots required the use of Animo's multiplane camera. The levels were set at various depths in relation to the camera, so that as the camera moved the effect of the parallax could be seen in the resulting sequence of images.

Special FX

Animo provides a number of special FX nodes and several were used on these ads. Where tonal shadows and highlights were required a new palette was created with a changed set of colours to match the shadow or highlight effect. This was done quickly and easily using Animo *ColourCorrector*. The new palette was applied to a second instance of a level which, in turn, was cut by the tonal matte. The *Matte Over* node composits the two instances of the level together to add the matted tonal areas on top of the original colours. By adding a blur to the matte the tonal area can be made soft-edged.

To create the drop-shadows, a second instance of a level was slightly displaced using a *Move* node. A *Silhouette* node was added to colour the level all black, and an *Opacity* node was set to 30 per cent opacity. A *Blur* node softened the shadow effect. Because the drop-shadow is derived from the same level as the character it tracks the character's action automatically.

Another filter effect that was used was the *Lighting* filter. This creates a backlit effect, as if extra coloured light is overexposed into the image to create a glow. It was used for a shot where the family, in a darkened room, is watching a television that casts a flickering rim-light glow upon them.

One shot required dissolves between several actions within a thought bubble. This was easily achieved by animating *Opacity* nodes between 0 and 100 per cent, using slow-in/slow-out timing that ensures the mix of images adds up to full exposure. This technique avoided the expense of compositing such complex shots in post-production.

Output

The result of the compositing and FX work was frequently checked by rendering AVIs with sound. Once we were satisfied that the shot was correct in all details, it was rendered to disk at output resolution using a rendering network of all available processors. In this case we rendered the TGA file format at PAL resolution with a gamma value of 1.0. Once each shot had been rendered to disk, the folders containing the thousands of TGAs were cut onto several CD-ROMs and delivered to the post-production facility at Anglia TV.

Post-production

The TGAs were read off the CD-ROMs to a large hard disk. Non-linear editing software was used to cut the shots together and match them with the original dialogue recordings and the sound effects track. A character generator was used to create the end graphic card, and the final ads were recorded onto Digital Beta tape.

Conclusion

The four 20-second ads were put together by a team of two, a designer/animator and a computer operator. As usual in this business, the deadlines and the budgets were tight. It was the first experience the client company had of using animation to promote their services. The use of animation software, in this case Animo, considerably decreased the time needed for all the post-animation processes, as well as providing the means to create quick colour proofs and impressive animatics for the pre-animation planning stage. The transfer of digital information via the Internet enabled quicker communication between the production company, the ad agency and the client company, resulting in less hold-up in getting on with the job. The ads were successfully broadcast over the festive season and the client is keen to continue this campaign.

Fig. 8.5 Clip from the finished commercial.

Alan Rogers and Peter Lang at The Cut-Out Animation Company use CreaToon

CreaToon is a simple system created specifically for cut-out methods of animation. It does not allow for the initial creation of images within the system, but is designed only for manipulating already prepared artwork, as you would under the camera. The results can then be prepared for rendering out to a video recorder or some other third party process.

Alan Rogers will prepare the artwork in several different ways. Usually, he first creates artwork using the normal tools of paints, inks, airbrushing and crayons on paper and scans the completed work into PhotoShop. If necessary, he then touches up or adds other elements and

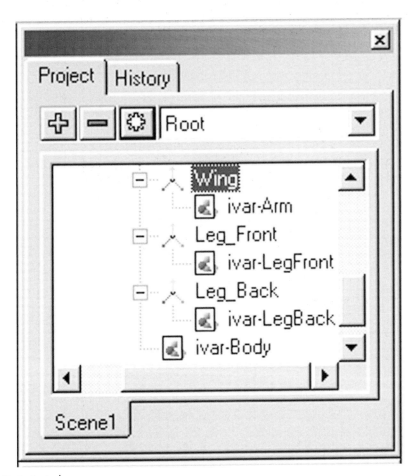

Fig. 8.6 *Project* window.

produces finished files as single elements of a character ready to load into CreaToon. Another time he might scan in the line work only and then colour it in PhotoShop or another bitmap system like Painter (produced by Meta-Creations).

'I even sometimes combine the two methods by doing the ink colour washes on paper, then adding airbrush in PhotoShop. I particularly like combining the old with the new.'

Backgrounds and characters are loaded into a hierarchical format within the *Project* window. A character might consist of separate body and heads, arms, legs, feet etc. These are then pivoted together within the *Project* window using dummies and layers to construct the objects together ready for placing 'under the camera'. All the elements of the characters and backgrounds are loaded into the computer and stored within the *Image resources* window. From here any required element is simply dragged into the *Project* window and placed within the hierarchy.

Fig. 8.7 *Image resources* window.

Once all the artwork is selected and placed within the different layers and levels it is necessary to allocate keyframes along the timeline in the *Keyframe editor*. Different key icons in the editor can be selected to determine a hold, inbetween, or blank as different items of the character are placed along the timeline. Also by highlighting the tools window an object can be made to rotate, scale or even turn in third dimension.

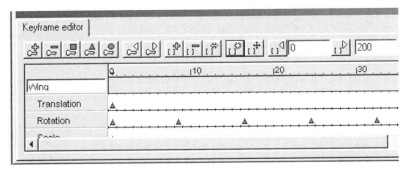

Fig. 8.8 *Keyframe editor.*

The *Properties* window allows for further elaboration of the character. The colour or opacity of the object can be changed and animated by defining keyframes along the timeline. The amount of scaling or rotation can also be controlled accurately here by typing in the required values.

At any time, an up-to-date replay of the animation can be viewed in the *Camera* window using the *Animation Controls* window. The replay response is immediate without the system having to precalculate the latest actions. When the scene is complete and ready, it can be rendered out

Fig. 8.9 *Properties* window.

Fig. 8.10 *Replayer.*

through the *Render Settings* window. The choice of image ranges from TGA, JPEG, BMP, PNG and AVI files with choices of configuration for different aspect ratios, i.e. widescreen or academy, for example.

Finally, Peter Lang, who does all the final computer composition and editing, uses *SpeedRazor* post-production facility on another computer to edit the video together. It is during this process that any further enhancements or effects are incorporated.

Alan: 'To begin with, as we use cut-out techniques' we endeavoured to animate book illustrations effectively. We wanted that look of moving book illustrations as opposed to cartoons, which were just flat colour and black outline.

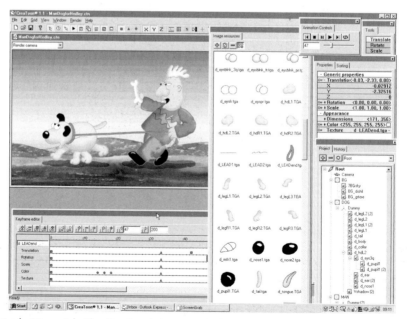

Fig. 8.11 *Fetch.* (Copyright The Cut-Out Animation Co.)

case studies 143

'We had always worked on paper, which gave us the style of drawing we preferred, instead of using cel acetate.

'When we looked at other systems originally, we saw that some were too expensive for our needs when we were only going to use a corner of the package.'

Peter: 'It was very difficult in the beginning when we first changed over to using computers – to make that initial "leap of faith" – And we had to risk it! We had started an actual job at the time, so we just had to get on with it. There was no time for playing and trying it out. We just had to learn as we went. How we would have done without Androme's help I shall never know.' (They are the company who produced the software.)

Alan: 'I do the artwork on paper using paint and crayons, scan them into PhotoShop and save them as PSD files. I then convert them to TGA files, the type of files CreaToon uses, when the artwork is complete and ready for handing over to Peter for animating in CreaToon. Quite often I may do the outline in black and add the colour in PhotoShop. I rarely draw in the computer, but I make a lot of amendments there. Although I use a wacom board I still prefer to do the original material with pen on paper. I find that much easier. For me, I find if I want to draw a curve on paper, I just turn the paper around, but on a wacom board you can't do that. You are completely at odds with your screen, and I find myself clambering over the table to come at it from another angle. I just can't see how people can do that!

Fig. 8.12 *Box.* (Copyright The Cut-Out Animation Co.)

'So, we still felt we wanted to bring our own drawings to life, and that was the whole point of the exercise, to start with. We weren't there just to entertain the use of a computer. We promised ourselves that *we* would dictate how the drawings would appear and not have to compromise and adapt to a new style of animation.

'We have just done a new series for BBC this year using the same characters as previous years and the results are exactly identical. In fact, there have been some pluses. The overall quality has

been improved. We've got all the textures of the paper in there. It doesn't look like a traditional cartoon. It looks like our old stuff, but better quality.'

Peter: 'We had also looked at CelAction which is a similar package, but we had to decide on one system only and we were already down the line with CreaToon, so we stayed with it.'

Alan: 'Sometimes we need to use overlays and that can get quite complicated, but at least there's no shadows using the computer, and nothing moves by mistake.

Fig. 8.13 *Falling Apart.* (Copyright The Cut-Out Animation Co.)

'In PhotoShop I use the *Cloning* tool the most, especially where I need to extend a background or cut and paste bits and pieces. The parts of the character are then drawn on white paper and scanned in. Cutting out the image in PhotoShop can be done mechanically using *Magic Wand*, but to make these TGA files work so that we can use transparency within the shot it is necessary to use a quick mask. When you alter the alpha channel settings in a shot, say to create a semi-transparent mist, it can cause problems with the registration of the masks. To avoid this, I first extend the artwork slightly bigger by thickening the black outline and then build in a quick mask of about three pixels to reduce it again. It does sound complicated and it is a fiddle, but sometimes it is necessary to prevent white lines appearing around objects making them look very cut-out.'

Peter: 'CreaToon was developed by 3D software designers, so it does include some 3D facilities. However, there are no special filter effects. For example, if I want to blur something, I can do it in *SpeedRazor* when I come to edit or Alan can change separate elements in PhotoShop before they are loaded into CreaToon.'

Fig. 8.14 *George the Fish.* (Copyright The Cut-Out Animation Co.)

Alan: 'But then, we still want to stick to this brief of keeping the traditional cut-out style, so we wouldn't need to use a vast range of effects. We see the system only as a vehicle for manipulating solid objects on film. Under the rostrum camera the method of using cut-out had always been very spontaneous. We would sometimes leave an eyeball clear white and Peter would add the black pupil using a chinagraph pencil, which could be wiped off again and replaced for a different expression. The freedom to ad-lib in that way is restricted a little using computers, but we approach our methods in a different way now. We can't just add a little line here and there or slightly change an expression on a character if the artwork has not been loaded in to cover it. That has always been one of the pluses of cut-out animation used under the rostrum camera. These days we just have to predict more accurately the images we require for the job before we start working on the computer.'

Peter: 'We have tried making a stock library of expressions but, for instance, you can't expect one eyebrow from one film to fit another. The drawing style alters.'

Alan: 'One of the great advantages of adopting the use of computers is the ease of copying artwork. When we were working on a series and using rostrum cameras, sometimes the tight time schedules caused us to employ other artists and camerapeople to help shoot the work, which meant that I had to supply them with copies of the artwork. This meant, at times, doubling up and having to do twice the amount of work. With computers the files can be copied and sent out to other studios if necessary, and you can make as many copies as you like. We were sending material to Belgium. It was being worked on over there, and when it was sent back, Peter tweaked it here and there. The process worked very well. Also, we couldn't scale up our turnover by taking on more work, but now we can. When we've produced a walk cycle we've kept the basis for another character. We can equally save work by flipping existing artwork

Fig. 8.15 *Mum.* (Copyright The Cut-Out Animation Co.)

within the computer. This can halve the amount of work necessary at times. But I don't like to do this with textured artwork, because the grain runs in one direction. It does not look the same when it is flipped.'

Peter: 'When Alan converts the PhotoShop files into TGAs we are not able to keep perfect registration. Some of the registration advantages that PhotoShop layers provide are lost, but this is not really a concern for us. Of course, in drawn animation using cel and paper, registration is essential, especially when the cameraperson does not know where to place characters in the scene if the drawings are not punched to match a pegbar. Cut-out has always been a free method, standing on its own, where objects can be placed where needed and then moved around as required.

'Finally, I must tell you this story. A famous cut-out animator mischievously told his students at a lecture how he had used Spraymount to stick his characters against the background while

Fig. 8.16 *Camera* window.

manipulating the bits of artwork under the camera. Of course, when the students tried this and ruined their artwork they were all the more impressed by his expertise!'

Since the time Alan and Peter started with CreaToon there have been some new features added with the release of the latest version, 1.2.

- Animations from one scene can now be imported into another without having to redo all the work.
- New shortcuts for animation tools have been added.
- An automatic clean-up of image resources.
- A choice between 25 or 30 fps (frames per second) for instant real-time previewing and rendering.
- A new orthographic and perspective camera mode.
- A play selection option for previewing a specific part of your animation.
- It is now possible to add text.
- Spline view: more control while fine-tuning the animation.
- More choice of aspect ratios while outputting.
- The history keeps track of the last 40 actions so that *Undo/Redo* can be applied at will.
- Greater enhanced user interface; more direct functions for composing the animations.
- Groups permits the allocations of cells in a list.
- With multiple cameras cuts can be made between camera viewpoints. All cameras can be moved (pan, zoom, roll).
- The *Copy-node* tool in the *Project* window quickly creates copies of objects in the scene.
- *Copy-frame* and *Move-frame* tools in the *Keyframe editor* quickly create copies of keyframes to the same or other objects in the scene.

CreaToon software is free to download from their website at www.creatoon.com as an unregistered (demo) version. A watermark is superimposed on any rendered images but can be eliminated if you order and pay for the full version.

Marie Beardmore shows how AKA Pizazz uses Toonz

Technological advances in software do not necessarily mean that the animator is obsolete or the skills crafted over the years are not needed. Some of the best packages work to bring the best out of artists, to complement rather than compete with them.

Toonz is an ink and compositing system designed for traditional 2D cel animators for the creation of film, video and interactive media. Toonz is not a vector-based system, which means that it's not a drawing package. So, all artwork has to be scanned in from original drawings, but once that is done the package is incredibly versatile and allows the operator to do anything to manipulate the image as well as export and import from other applications, such as PhotoShop, with ease. Toonz does not take the art out of the animation process but rather simplifies it through a comprehensive toolkit which means everything is at hand. The kit includes tools for importing original pencil drawings and adding changes when necessary; building colourmodels; ink and paint; creating exposure sheets; compositing; creating special effects and recording the final images on video or film.

AKA Pizazz is one animation studio that finds Toonz invaluable in the workplace. Here three very different case studies show its versatility. All examples used Toonz 4.3.

Fig. 8.17 Compaq commercial.

Compaq

Compaq builds servers for the Internet and wanted an advertisement that showed the many types of business that could benefit from using their hardware. The brief was to use a spider's

web as a metaphor for the Internet, which would show different animated sequences as it spun around.

The agency wanted a thirties look so the ad was made in black and white and aged to recreate that feel.

There were 18 scenarios in all, each depicting a scene, such as fashion, oilfields (to illustrate stock trading), astronomy, bellhops (for hotels), and dinosaurs for archaeology. Toonz works from drawings which are scanned in so they can be sequenced and manipulated to create the look and feel required.

Fig. 8.18 Compaq commercial.

The aged effect was created by putting a blurred level behind a sharp level, to give different layers, which is easily achievable on Toonz because it allows the fluid manipulation of levels and fields.

In this case, there was not really a colour process as the images had to be in black and white. However, shading and lighting effects had to be added and the whole look aged, which took some time. Art is rarely a precise science so getting the shading levels right was not a one-off process. Getting the look right in the restaurant section was particularly involved because Fabrice Altman, Toonz operator, needed to create lighting and shadow to recreate light streaming through the windows. Toonz works well here because these layers of light and shade can be applied one layer at a time. But even with the versatility of Toonz, it is still an involved process. Fabrice explains: 'The way Toonz works, with effects and mattes, you can't see what is happening straightaway, so you have to wait a minute for one still image to render and then you can see what you're working with.'

To get the finished look, Fabrice built up the image a layer at a time, literally a shade at a time, then rendered the image so he could see what it looked like. The final light and shade is believable but does not compromise the aged look of the sequence.

Fig. 8.19 Shadowing and lighting effects.

One of the sections, astronomy, involved compositing 3D animation for the backgrounds. Instead of a straightforward PhotoShop background, a 3D sphere planet was used. The sphere looked like a world map with longitude and latitude lines drawn over it. This was done on Softimage 3D and imported into Toonz at a rate of 25 frames per second to create a moving background. The stars were made in Softimage 3D Particles Suite where they were animated in order to make them sparkle.

Fig. 8.20 Spinning web.

Getting the web to spin just right also took some adjusting. Even though the final web was done in post, Fabrice used Toonz to get the camera angles and timings just right so they could be easily replicated in post. Working on something so meticulous without Toonz would have been a much more time-consuming process. With Toonz, it is easy to get the right camera angles, and if you do not like a shot it is no problem to change it or start again. Toonz still needs a skilful

operator but does away with some of the more painstaking and tedious elements of work. The final spinning web was achieved by trial and error. Says Fabrice: 'It took about two weeks to get the web spin right because there were many ways it could move, so it took a few weeks to get the agency's final approval; the web was spinning either too fast or too slow.'

Meadow Hall – a shopping mall

A different use of Toonz was the Meadow Hall advertisement. While Compaq wanted something black and white with a thirties feel, the Meadow Hall brief was very different. Meadow Hall is a shopping centre in Sheffield, England, so the agency wanted to sell it on convenience and variety. They wanted a modern feel with colourful, friendly and accessible characters. The brief was to depict a woman and her baby walking through a shopping mall, all done to a realistic voice track. There were five ads in all, but the one that made the most use of Toonz was the pram ad. In this, the central character was walking and talking and pushing her pram through the aisles and browsing at the many shops in the centre. Fabrice created the illusion of walking by panning and shrank the aisles accordingly, to give the impression the character was moving through the mall.

Fig. 8.21 Meadow Hall commercial.

As director, Mick Graves bears in mind what Toonz can do when thinking about an ad. 'The process of working has changed a lot. The difference in working on camera and working on Toonz is that Toonz is much more flexible in terms of decisions that can be made at the last minute. In animation that is quite important as although there are lots of things that are about forward planning and lots of things are set in stone, it is nice to have that little bit of freedom which Toonz allows. You can change something last minute, say the angle of the aisle, which in camera you would not be able to do without building up costs. Toonz enables us not only to keep to tight deadlines but also to keep stuff in house; we can reshoot and change sequences very easily. The agency might want changes and we can do those with a quick turnaround.'

With Meadow Hall the changes were things that were easily achievable with Toonz, like making shop names bigger, which is a key consideration in a shopping mall ad. The agency were happy

Fig. 8.22 Meadow Hall commercial.

with the colours and the way the backgrounds were being moved and they were very happy with the animation. Says Mick: 'The beauty of Toonz is it's flexible. You can drop in something and re-output it, whereas that would be an absolute nightmare in camera and would put the costs up.'

Colour work was an important consideration of the Meadow Hall ad. To achieve the look he wanted, Fabrice used a mix of the Toonz palette to get the right tones – Toonz has a 256-colour palette and the same number of inks. It was important to depict as many shops as possible in the ad as it was selling the variety of stores on site at Meadow Hall; Fabrice used eight icons to denote the eight shops in the ad and each icon had to be individually lined in ink. Marks & Spencer was illustrated with underwear on hangers, Boots was represented by clocks, Wallis was denoted by trousers. Although straightforward, this was the most time-consuming part of the process for Fabrice. Each item had to have an ink outline which had to be self-traced, so Fabrice had to paint the outline on each drawing. On the woman, strands of hair had similarly to be painted individually.

Creating the outline around the main character was one of the more technically difficult aspects of the job, but Fabrice found a short cut that saved time, which is crucial on tight deadlines and a tight budget.

Fig. 8.23 Meadow Hall commercial.

'I was asked to create the outline and normally I'd need to make a separate matte. However, I found that by using Toonz in conjunction with PhotoShop, it was possible to construct the outline from the matte of the character. With Toonz this is easy because it allows you to import and export from other applications, in this case PhotoShop, very easily.' To create the white edge 'halo effect' he needed, Fabrice rendered the character and sequence then applied a filter in PhotoShop, which grew the shape of the character. This was then reapplied in Toonz underneath the character to create the white edge.

Smarties

A different application for Toonz was used in a Smarties ad, which was created for the TV show *Diggit*. Here the look was different again – modern and edgy – but it was the construction of the characters that took the most time. The characters were drawn as outlines in the same way as the Compaq ad, but because they were to look as though they were made in different pieces of fabric, the drawings were actually put together in kit form, so that each moving part is an individual image. For some of the characters there could be 30 or more parts. All of the stings were created in the same way but the example used here is of a sting called Doctor in which the Doctor asks his patient to show his tongue and he does so to reveal it covered with Smarties.

Fabrice was provided with a hand-drawn animation guide and a kit of parts with different textures, which were all created in PhotoShop. He followed the animation guide and dope sheet

Fig. 8.24 Smarties commercial.

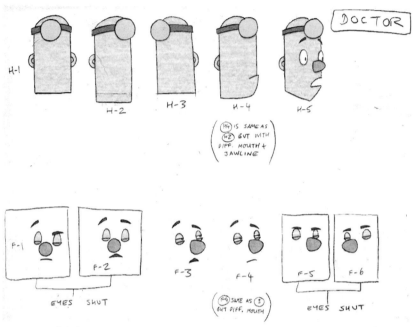

Fig. 8.25 Doctor model sheet.

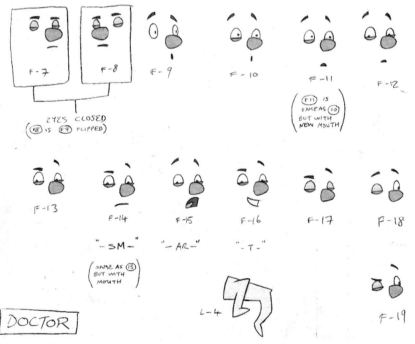

Fig. 8.26 Doctor model sheet.

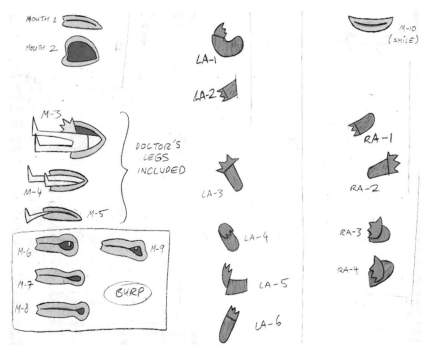

Fig. 8.27 Doctor and patient model sheet.

to make each bit move as it was supposed to. Toonz allows the user to see the dope sheet on screen so that changes can be made easily.

The layering ability of Toonz was invaluable on the Smarties ad which sometimes used 30 layers, each of which had to be adjusted every two frames (12 frames per second) to create movement.

For this, Fabrice used the Toonz *Camera* stand view, which allows the user to manipulate the foreground and background layers with ease. It also allows the user to move each part frame by frame, which was especially important when dealing with a character constructed from several moving parts.

Director Marc Craste comments on the Smarties ad: 'The stings all ran from one original 30–40 second ad which was done in a pseudo cut-out animation. Doctor is one of seven stings we created from the ad. We wanted something rough around the edge but getting the look right was a good challenge for the animators. I think it has a nice look and one which I had tried before for an Orange commercial, which was never screened but it did give me the idea. I think Toonz is a great package. I really like its layout, but as with all these things a lot of its success comes down to the operator. They have to be willing to try different things and see what can be achieved. It's also great for camera moves. In another Smarties commercial we showed some children in a zoo and used Toonz first to get all the camera angles before going into post. Virtually everything we do here at AKA Pizazz goes through Toonz at some stage.'

Fig. 8.28 Smarties commercial.

glossary

Account. Name given to a user's own position in the network of computers or on an individual workstation. If there are many users on a network it is essential to identify each individual with their own identity so that personal preferences can be established and security maintained.

Alignment. The scaling and orientation of an image within the screen.

Alpha channel. In a 32-bit bitmap there are Red, Green and Blue pixel values. The alpha channel is an additional transparent one. TIFF, TGA and PICT files support this channel but not all bitmaps do.

Animatic. A storyboard that has been processed onto video or film with a soundtrack to give an audience a better idea of the finished product. A **Leica reel** is a further development of the animatic where more movement and, sometimes, limited animation is used to create a better understanding of the final film.

Anti-aliasing. A form of processing computer-generated images which counteracts the jagged edges, which would be present without it. These are caused by the low resolution of the screen showing the image.

Anticipation movement. A rule of animation that dictates that an object cannot just move from a static position without starting a movement in the opposite direction first.

Application. One of many departments of computer software that allows the user to process work. May also be known as a program.

Application error. A computer message that advises the user when a program is not functioning correctly.

Aspect ratio. The ratio between the width and height of the screen image. The aspect ratio for standard TV images is 4×3.

Auto-save. Most computer systems use an auto-save function to some degree or other to save work automatically at regular intervals.

AVI. Audio/Video Interleaved. The file format used by Windows operating system for combined video and audio data.

Background. Usually, painted artwork scanned into the system and used as a backdrop to an animation scene.

Back-up. A way of storing software files of work done on some form of tape or CD. It is essential to back up your work in case any files are lost or destroyed.

Beziér. A method of defining curved lines invented by the French mathematician, Pierre Beziér.

Bgtiler. (Toonz) A way of assembling images made up of more than one part in the scanning background process.

BIOS. Basic Integrated Operating System. A term used with computer motherboards.

Bit. A binary digit used by the computer as the smallest unit of information.

Bitmap. A standard file used for pictures containing an image defined by a matrix of coloured dots, having a finite resolution. Therefore, used in close-up the image will lose its clarity.

BNC connector. A twist-lock connector used on some VTRs, monitors and video equipment.

Boot, reboot. A term used for starting up a computer. When you switch on the mains the computer goes through a self-checking procedure and then presents an opening display to the user; this is known as booting up. You will sometimes need to reboot your computer to escape from a system failure, or after new equipment has been installed in the computer or network. Never reboot without trying all the shutdown procedures first.

Byte. A unit of data made up of eight bits.

Calibration. The adjustment of colour or black and white values in a scanner.

CD-ROM. Compact Disc Read Only Memory. A removable disk that holds computer files.

Cel. Clear cellulose acetate plastic sheets used in traditional animation, usually drawn on one side with black ink and filled in with emulsion paints on the reverse.

Chroma key. A video term used to describe the process of combining an animation character over live action by recording the artwork against a single colour background, and superimposing this image afterwards during editing. In some of these computer systems the combination can be made in the final composition.

Click, double-click. To press and immediately release the mouse button (the left mouse button if you are using a two-button mouse). Do this twice in quick succession to double-click. Users with a pen and tablet click by tapping the pen on the tablet.

Client. A computer workstation connected to a controlling computer called the **server**, on a network.

CMYK. Cyan (Blue-green), Magenta, Yellow, and Black. A process of identifying colours used by printers.

Colour wheel. A display of the colour spectrum in the form of a circle. You can usually choose colours by clicking in the colour wheel.

Cove. A term used more in live-action studio filming or stills photography as a colour graded background, originally created by bending a large sheet of card and playing coloured lights across it.

Cover sheet. Used in Animo's *Director* as an on-screen form allowing you to fill in details about the scene, such as its length, title, who worked on it, camera aspect ratio and so on.

Crash. The term describes the computer completely seizing up or failing in some way where the user loses complete control. All systems crash at some time during the work process; this is why saving is so important.

Cursor. The on-screen pointer that shows the position at which you are working. It may take many forms, depending on the tool or application used.

Cycle. A sequence of drawings, creating a movement by repeating themselves. For example, a walk cycle might contain eight or more drawings which repeat for a complete continuous movement.

DAT. Digital Audio Tape. A format used for storing audio material or computer data.

Data. Computer information.

Default. A predetermined setting or value selected by a computer application when the equipment is first turned on, after which the user may then adopt an alternative value or setting.

Defragmentation. With constant use many computer files become fragmented, spread over different areas of the hard disk. This may slow up the speed of the computer. A disk defragmenter is recommended to sort out the files on the hard disk and improve performance.

Delete. Remove. Deleted items are usually irretrievably lost.

Desktop. The primary workspace on the computer screen.

Disk. Magnetic storage medium for computer data. There are fixed disks in most computers, and floppy disks for removable storage of small amounts of data.

Disk drive. The hardware disk which stores the main files.

Disk recorder. A disk-based storage device designed for fast access to, and storage of sequences of, images, either generated by computer, or from other video sources.

Dope sheet. A type of chart, used in traditional animation, containing notations and instructions for a cameraperson to follow while filming the animation artwork on a rostrum camera. Also known as an **exposure sheet** or **XSheet**.

DPI. Dots Per Inch. The standard measure of resolution for computerised printers and scanners. The dot is the smallest discrete element making up the image.

Drag. Action of an object on the screen controlled by holding down the left mouse button while moving the mouse or pen in any direction.

Drawing window. (Animo) One of the main windows in *Director*; shows the objects in the scene.

Driver. A software program used by the computer to instruct peripheral devices.

Email. Electronic mail. System of electronic communication that allows the user to send messages (and sometimes pictures, sound etc.) anywhere else in the world connected to the email network direct from his or her own workstation.

.EPS. Encapsulated PostScript file. A standard format for storing graphics.

Ethernet. A system of data communication between computer devices. Your network (if you have one) uses Ethernet to transfer data between the workstations on the network. The term Ethernet can refer to the physical components (cable, connectors etc.) as well as to the software that operates the transfer.

Exposure sheet. Dope sheet. In computer systems, it is also referred to as the **XSheet**.

Fairings. The 'cushioning' and timing of drawings and camera movement.

FAT. File Allocation Table. A method used by operating systems to locate files stored on the hard disk.

Field chart. Also known as a graticule. A grid used for aligning images to the screen. In traditional animation it is also used to define areas of artwork, size, rotation and position in relation to the rostrum camera.

Filmclip. Sequence of images imported into the computer to form part of the final output image.

Filter. Processing applied to the generated image in order to create effects such as blurring, rippling etc.

Focus pull. In live-action filming the camera may pull focus on a scene by shifting the attention from distance to close up, or vice versa, altering the depth of field and creating a blurred background. The same effect can be created with computer animation using multiplane and blur filters.

Folder. Collection of files on the computer disk.

Follow through. An action in animation drawings that obeys the law of motion that when an object is abruptly stopped, a part of the body of the object continues to follow its direction. If this rule is applied correctly it adds weight to the action.

Frame. A single picture on a roll of film. There are 24 frames in a second of projected film, 25 in a PAL TV sequence, and 30 in an NTSC TV sequence.

Grab. To acquire a still image from an external source, usually a video source, or to capture a single image from the screen of the computer for use with another application or third party software.

Hardware. The physical components of the computer system, most usually referring to the hard disk, memory, motherboard, etc. Something contrasting and opposite to **software**.

Hold. Frames within the animation sequence when a character or object maintains its position without moving.

HSV. Hue, Saturation, Value, or brightness. A method of defining colour.

Icon. A small picture, usually held on the desktop, representing an application, program, disk drive, file, folder, or other item. Double-clicking on the icon starts the program.

Inbetween. A frame or animation drawing created between two key drawings or keyframes. In computer animation certain types of keyframes are produced by the system automatically.

Interface. The display and the style of information presented by your computer screen.

Interpolation. The insertion of frames of animation as inbetweens, created by the system based on its estimation from surrounding known values. A form of automated inbetweening.

JPEG. Joint Photographic Experts Group. An international standard file for compressing images.

Key. The first or last position drawing in a sequence of animation. Key drawings are usually created by the animator.

Keyboard modifier. One or more keyboard keys which, when held down, modify the way in which the current operation is performed.

Keyboard shortcut. One or more keyboard keys which, when held down, cause an operation to be performed.

Layout. A drawing of the background and, perhaps, animation characters, created at the planning stage of production, describing visually the main features of the scene.

Leica reel. See **Animatic**.

Line test. A filmed preview of simple line drawn sequences of animation.

Lip-sync. The synchronisation of a character's mouth drawings to a sound track.

Log in. Log out. Logging in is the process of identifying yourself to the computer and gaining access. All users of the computer must have an identity. Before you can use it, you have to log in, using your name and password. When you have finished, log out so that the computer knows that the next user may not be you.

Matte. Also known as frisket (an old term used in printing) or mask. A flat area, usually black, used to mask out a section of the image on screen, replacing it with another image.

Memory. Also known as RAM. Part of the computer system devoted to short-term storage of data.

Menu. A list of commands displayed on screen showing options and facilities available.

Modem. Device used by computers to translate computer signals into a form which can be transmitted over telephone lines for email and Internet use.

Monitor. Computer screen.

Mouse. Mechanical pointing device with one or more buttons.

Network. Connected group of workstations exchanging data and sharing resources.

Node. A component on a network. In Animo, it is an essential component within *Director*, used to load a drawing file, image, effect, or positioning command into the scene.

NT. Computer operating system with Windows interface.

NTFS. New Technology File System. A file system designed specifically for use with Windows NT.

NTSC. Television standard used in the USA and some other countries.

Operating system. The basic software devoted to managing the general operations of the computer.

Output. The last task and finished product of the software system, where the final composition is transferred to a suitable recording device.

PAL. Television standard used in the UK and other countries.

Pan. Movement of the camera across a scene.

Password. A word or collection of letters/numbers that should only be known by the individual user logging in to a workstation.

Pegbar. A metal bar with three upright, particularly shaped, pegs for registering drawings and artwork.

Peripheral. Piece of equipment attached to a workstation. Printers, scanners and film recorders are all types of peripherals.

Permission. Every file on your workstation can be accessed only by those who have the required permission. Every file has a set of permissions which define who can open the file and make changes to it. Files you create are automatically given the permissions that allow you to open and make changes to them. Files created by the system or by other users may not have such permissions.

Phoneme. The smallest unit of sound in language that distinguishes one utterance from another. Used in working with lip-sync.

Pixel. Smallest element of an image on a monitor or TV screen.

Port. Connection point on the computer chassis. Most computers have more than one port, into which items such as keyboard, mouse or peripheral equipment can be plugged.

Preferences. Set of controls allowing you to make changes to the way programs work.

Processor unit. The part of the computer containing the 'brains' and memory of the system. It usually has a number of disk drives allowing the reading of floppy disks and CDs.

Properties. Interface panel that displays and allows you to make changes to information on the selected object.

RAM. Random-Access Memory.

Render. In computer terms it means to generate a completed scene to disk or an output device. In traditional animation 'rendering' referred to the texturing of painted cels by the use of chinagraph wax crayons.

Replay. An application that allows you to see a preview of the animation scene.

Resolution. Number of dots per inch (DPI) or pixels making up an image when displayed on a monitor or reproduced on a device such as a film recorder or printer. These systems produce images which are resolution-independent; that is they have no finite resolution in themselves and can be reproduced at any required resolution, according to the capacity of the output device.

RGB. Red, Green, Blue. The primary colours used on a monitor or TV screen, and the basic components of a colour video signal.

Safe area. Some TV sets do not show the complete image produced in a full academy film screen. Therefore, important details, titles and graphics etc. must be contained within a reduced screen boundary, the 'TV safe area'.

Scanner. Device that converts a photograph or artwork into a bitmap image suitable for use on a computer screen.

SCSI. Small Computer Systems Interface. A standard connection interface that allows hard disks and other high-performance devices to be attached to computer systems.

SECAM. Sequential Couleur Avec Memoire. Television standard used in France and some other countries.

Server. A computer that controls other users' access to a network. The other users who share resources on the network are called **clients**.

Software. The programs, procedures and other operating information used by the computer. Something contrasting and opposite to **hardware**.

Spline. A curve or trajectory along which a character moves following different paths controlled by points. Depending on the software system these points are known as knots, weights or nurbs.

Squash and stretch. A rule of motion applied to animation drawings. An object will stretch in the direction that it is moving and squash immediately it stops against a surface. These laws must be applied in the drawings to give the action any strength and conviction.

Swish. A drawn effect, created by soft pencil lines or airbrushing, to simulate the blurred image of a character moving very fast through the frame.

System administrator. Computer user who acts as manager to oversee the operation of the network.

Tablet/pen. An alternative device used instead of a mouse and mousepad to control the cursor.

Text field. A box on the screen for information to be typed in.

.TGA. A standard graphics file format designed originally for video use and commonly supported by MS-DOS colour applications. The TGA format consists of a 32-bit RGB file with a single alpha channel, thereby allowing for the use of transparency.

.TIFF. Tagged Image File Format. An industry standard bitmap image format supported by many applications.

Timing. The arrangement of drawings, speed of movement and positions within a scene governed by a specific length of time. This is usually defined in the XSheet. It may also arrange drawings to be 'shot' on singles, doubles, reverse order or randomly, etc.

Timeline. The columns in the XSheet that define the speed of a character's or camera's movement by the placement of keyframes along its length.

Toolkit/Toolbar. A set of software buttons or collection of commands for processing work.

Track. Can also be known as Truck. A camera movement closing in on the scene or pulling out. In animation this is a different movement from a pan. Can also be incorrectly confused with **zoom**. (During the times of the great naval battles, fought against the French and Spanish, ships' guns were mounted on small, rectangular, wooden wheeled carriers. These were called 'trucks'. Later, the film industry adopted the word to describe the vehicle that carried the mounted camera along a railed track.)

TWAIN. Technology Without An Interesting Name. An industry standard protocol for exchanging information between applications and devices such as scanners.

VCR. Video Cassette Recorder. Usually refers to a domestic machine.

Virtual memory. Temporary space on a hard disk.

VTR. Video Tape Recorder. Usually refers to a professional video recorder.

Well. Storage space for colour in the *Ink and Paint* palette, or other interface items.

Window. A rectangular area in which information is presented on the screen. Systems sometimes need to display many windows on the screen to show the performance of different operations.

XSheet. In many systems the XSheet refers to the final application where the completed scene is put together. In Animo, the final scene application is called *Director* and the XSheet is only a part of that program. Also, see **Dope sheet**.

Zoom. The enlargement or reduction of the image created by adjusting the lens on a video camera, while the camera itself remains still.

Index

Note: Page numbers in bold indicate a significant amount of text on the subject.

 Focal Press

http://www.focalpress.com

Join Focal Press On-line

As a member you will enjoy the following benefits:

- an email bulletin with **information on new books**
- a bi-monthly **Focal Press Newsletter**:
 - o featuring a selection of new titles
 - o keeps you informed of **special offers, discounts and freebies**
 - o alerts you to **Focal Press news and events** such as author signings and seminars
- complete access to **free content** and reference material on the focalpress site, such as the focalXtra articles and commentary from our authors
- a **Sneak Preview** of selected titles (sample chapters) *before* they publish
- a chance to have your say on our **discussion boards** and **review books** for other focal readers

Focal Club Members are invited to give us feedback on our products and services. Email: worldmarketing@focalpress.com – we want to hear your views!

Membership is FREE. To join, visit our website and register. If you require any further information regarding the on-line club please contact:

> Emma Hales, Promotions Controller
> Email: emma.hales@repp.co.uk
> Fax: +44 (0)1865 315472
> Address: Focal Press, Linacre House,
> Jordan Hill, Oxford,
> UK, OX2 8DP

Catalogue

For information on all Focal Press titles, we will be happy to send you a free copy of the Focal Press catalogue:

USA
Email: christine.degon@bhusa.com

Europe and rest of World
Email: carol.burgess@repp.co.uk
Tel: +44 (0)1865 314693

Potential authors

If you have an idea for a book, please get in touch:

USA
Terri Jadick, Associate Editor
Email: terri.jadick@bhusa.com
Tel: +1 781 904 2646
Fax: +1 781 904 2640

Europe and rest of World
Christina Donaldson, Editorial Assistant
Email: christina.donaldson@repp.co.uk
Tel: +44 (0)1865 314027
Fax: +44 (0)1865 315472

Next title in the Focal Press Visual Effects and Animation series ...

Producing Animation
Catherine Winder and Zahra Dowlatabadi

- The *only* producer's overview of the animation industry

- International, comprehensive guide to the management of the animation production process

- Includes exciting interview material from some top name industry talent including Roy E. Disney, Ann Daly (DreamWorks); Mark Taylor (Nickelodeon); David Sproxton (Aardman); Koji Takeuchi (The Telecom Animation Film Co, Japan)

Producing Animation offers a clear overview of the animation industry and is a comprehensive guide to the management of the animation production process.

This guidance starts from the identification and sale of a concept, through development, pre-production, production and post-production, to what happens when the project is completed. The negotiating process in the purchase and sale of a project, the assembling of the development team, the producer's role in the development process, budgeting and scheduling are all examined in detail.

Order your copy of this invaluable animation guide today!

April 2001 • 288pp • 234 x 180mm • Paperback • 40 line illustrations
ISBN 0 240 80412 0

Also available from Focal Press ...

Classic Animation Text

Timing for Animation
Harold Whitaker and John Halas

- Co-written by 'the father of animation' - John Halas

- Remains the standard authoritative work on the subject

- Illustrated with cartoons throughout

Timing is the 'invisible' art in animated filmmaking. Unseen and unnoticed by a cinema audience as they watch the screen, it can nevertheless be one of the prime reasons for the ultimate success or failure of a shot.

Written by two internationally acclaimed animators, this book explores the art of timing and its function in the animated film. *Timing for Animation* not only offers invaluable help to those who are learning the basis of animation techniques, but will also be of great interest to anyone already working in the field of animation.

1981 • 144pp • 246 x 189mm • Paperback • Line illustrations
ISBN 0 240 51310 X

Also available from Focal Press ...

The Encyclopedia of Animation Techniques
Richard Taylor

- Covers 2D, 3D, model and computer generated animation

- Explores conceptual and technical sides of creating animation

- Features an inspirational gallery section

- Includes a comprehensive list of international animation festivals

- Contains advice on how to submit your work

The Encyclopedia of Animation Techniques is a fully illustrated step-by-step guide to drawn, model and computer-generated animation. It offers professional guidance on all aspects of animation – from conceptualisation and script treatments to cut-out animation and puppet making.

Includes a gallery of more than 100 finished works from the world's leading contemporary animators.

"A masterpiece of professional guidance. It employs all the visual techniques of its subject matter to excite as well as to educate. With superb clarity of presentation, it cannot fail to inspire as well as inform animators of the future."
Kraszna Krausz judges

April 1999 • 176pp • 222 x 222mm • Paperback • Full colour throughout
ISBN 0 240 51576 5

Also available from Focal Press ...

The Art of the Storyboard: Storyboarding for Film, TV and Animation
John Hart

The Art of the Storyboard shows beginners how to conceptualize and render the drawings that will communicate continuity to the cinematographer, set designer, and special effects supervisor, or to create the skeletal outline around which an animated program is developed.

Using sketches of shots from classic films, from silents to the present, John Hart's book covers the history and evolution of this craft and discusses the essentials of translating one's vision onto paper, from the rough sketch to the finished storyboard.

Over 100 illustrations from the author's and other storyboard artists' work illuminate the text throughout.

Exercises at the end of each chapter help students to develop essential drawing and visualizing skills.

December 1998 • 223pp • 279 x 216mm • Paperback • 130 line illustrations
ISBN 0 240 80329 9

Read Me File

The Animator's Guide to 2D Computer Animation CD (PC only)

AcroRead – If you don't have Adobe® Acrobat® Reader on your PC double click on **Ar405eng** to load it so you can read the PDFs on this CD.

Movies – Contains: **Furry Tales and Worm** and **Nice Day**. Double click on these to load them via Windows Media Player, or install them via your preferred viewer.

Software – Each sub folder in this section contains demo material/information from the relevant software developer. The intention is to give you a taste of the different 2D computer animation software available. To purchase a full copy of any of these packages contact the developers direct; address details are included in the book in Chapter 7.

Animo v3.1 Demo – There is no installer for Animo Demo – the applications can be run directly from the CD. (See **README** in this folder for more information.)

Archer Demo – To run the demo load **autorun** and follow the on-screen instructions.

AXA – Contains a direct link to AXA's website to download a demo version of the package.

CreaToon V1.2 Demo – To run demo go to the **Website** folder and open the file **index** in your web browser. Alternatively, run **CreaToonSetup** and follow the on-screen instructions. (See the **Readme** file for more detailed information.)

Ctp – To run the demo open the **Ctp 1.1 Release 11** file. Read the **Read Me Licence** file for more information on how to purchase a licence.

RETASPRO Demos – To load each application run **setup** in the sub folders: CoreRETAS; PaintMan and TraceMan.

Toonz – Contains a direct link to the Toonz website for up-to-date information on this package.

toonboom demo reel – Showcases a variety of work produced using Toonboom. Double click on **Capture** to load via Windows Media Player, or install via your preferred viewer.

Thanks go to all the software developers of the above programs who gave permission to include this information and demo material on this CD.